DAILY
LOVE

DAILY

365 DAYS OF
CELEBRATION

LOVE

Photos and Wisdom to Boost Your Spirit

NATIONAL GEOGRAPHIC

WASHINGTON, D.C.

ISBN: 978-1-4262-1714-2

Since 1888, the National Geographic Society has funded more than 12,000 research, exploration, and preservation projects around the world. National Geographic Partners distributes a portion of the funds it receives from your purchase to National Geographic Society to support programs including the conservation of animals and their habitats.

National Geographic Partners
1145 17th Street NW
Washington, DC 20036-4688 USA

Become a member of National Geographic and activate your benefits today at natgeo.com/jointoday.

For information about special discounts for bulk purchases, please contact National Geographic Books Special Sales: specialsales@natgeo.com

For rights or permissions inquiries, please contact National Geographic Books Subsidiary Rights: bookrights@natgeo.com

Interior design: Katie Olsen

Printed in China

16/PPS/1

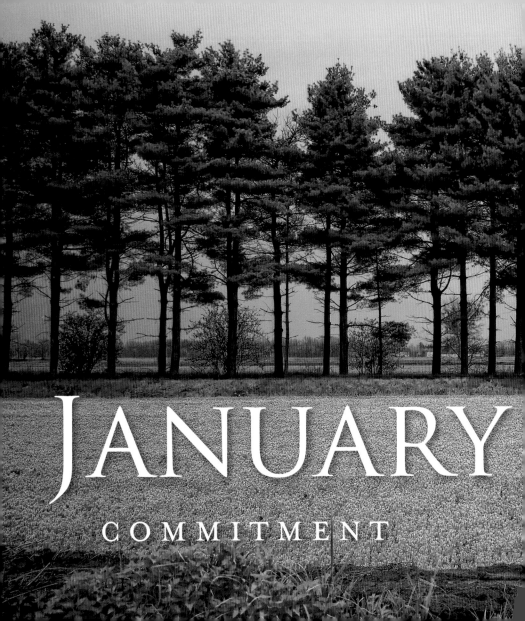

JANUARY
COMMITMENT

READ. BREATHE. LAUGH.

with *National Geographic Books*

Experience all of life's pleasures with Daily Calm, Daily Gratitude, Daily Joy, and Daily Peace. In these elegant books, 365 days of stunning photographs are paired with meaningful reflections that will uplift and nurture you every day of the year.

 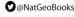

Acknowledgments

Daily Love would not have been possible without the hard work of the wonderful National Geographic team: senior editor Hilary Black, project editors Anne Smyth and Allyson Dickman, researchers Lindsay Anderson and Kris Heitkamp, designer Katie Olsen, photo editor Uliana Bazar, and countless others who gave their time and talent to this book.

6, Jamie Grill/Getty Images; 7, joe daniel price/Getty Images; 8, Stephen Moehle/Shutterstock; 9, Robert Gendler/Stocktrek Images/Getty Images; 10, Sofiaworld/Shutterstock; 11, Adriana Franco/National Geographic Your Shot; 12, aslysun/Shutterstock; 13, BIHAIBO/Getty Images; 14, magdasmith/Getty Images; 15, Anna Berkut/Getty Images; 16, Ozerov Alexander/Shutterstock; 17, ViewStock/Getty Images; 18, Yuriy Kulik/Shutterstock; 19, Cristina Corduneanu/Getty Images; 20, Nobythai/Getty Images; 21, marcutti/Getty Images; 22, sandsun/Getty Images; 23, Image provided by Chang, Min-Chieh/Getty Images; 24, WIN-Initiative/Getty Images; 25, Anna Gorin/Getty Images; 26, Danita Delimont/Getty Images; 27, MarkSwallow/Getty Images; 28, serkucher/Shutterstock; 29, Jordan Parks Photography/Getty Images; 30, temmuz can arsiray/Getty Images.

OCTOBER

(Opener), RHainstock/Getty Images; 1, Nataliya Arzamasova/Shutterstock; 2, Photography by Marta Rhine/Getty Images; 3, Mitsuaki Iwago/Minden Pictures/National Geographic Creative; 4, Luboslav Tiles/Getty Images; 5, Galyna Andrushko/Shutterstock; 6, Josemaria Toscano/Shutterstock; 7, Ingine/Getty Images; 8, Kul Bhatia/Getty Images; 9, Fesus Robert/Shutterstock; 10, ROMAOSLO/Getty Images; 11, javarman/Shutterstock; 12, Robert Seitz/Getty Images; 13, RuthChoi/Shutterstock; 14, Marc Venema/Shutterstock; 15, Artur Stankiewicz Photography/Getty Images; 16, Christian Engel/EyeEm/Getty Images; 17, Yulia Reznikov/Getty Images; 18, Artens/Shutterstock; 19, cristinagonzalez/Getty Images; 20, SIME/eStock Photo; 21, Magdanatka/Shutterstock; 22, Peter Stuckings/Shutterstock; 23, Susie Cushner/Getty Images; 24, Caiaimage/Getty Images; 25, Chris Hill/National Geographic Creative; 26, Michael Grimm/Getty Images; 27, AVTG/Getty Images; 28, Dark Moon Pictures/Shutterstock; 29, Matt Propert/National Geographic Creative; 30, IlyaShapovalov/Getty Images; 31, Petar Chernaev/Getty Images.

NOVEMBER

(Opener), I_V_Y/Shutterstock; 1, SERDAR YAGCI/Getty Images; 2, VIDOK/Getty Images; 3, Peter Mukherjee/Getty Images; 4, Rike_/Getty Images; 5, Iuri/Shutterstock; 6, Michael Melford/Getty Images; 7, Michele Falzone/Getty Images; 8, Angus Clyne/Getty Images; 9, Alfredo Maiquez/age fotostock; 10, DanielPrudek/Getty Images; 11, Mac Stone/TandemStock.

com; 12, Subir Basak/Getty Images; 13, eAlisa/Shutterstock; 14, Frans Lanting/National Geographic Creative; 15, javarman/Shutterstock; 16, Raphael Abecassis/National Geographic Your Shot; 17, Massonstock/Getty Images; 18, Photo by Steffen Egly/Getty Images; 19, Jens Ottoson/Shutterstock; 20, Arthur Tilley/Getty Images; 21, jaboo2foto/Shutterstock; 22, Brian Hagiwara/Getty Images; 23, Andrew S/Shutterstock; 24, richardwatson/Getty Images; 25, Geribody/Getty Images; 26, Kichigin/Shutterstock; 27, Svetl/Getty Images; 28, StockImageGroup/Getty Images; 29, Helaine Weide/Getty Images; 30, Standret/Shutterstock.

DECEMBER

(Opener), Arctic-Images/Getty Images; 1, LeniKovaleva/Shutterstock; 2, PWT/Shutterstock; 3, David Fischer/Getty Images; 4, Leigh Ayres/National Geographic Your Shot; 5, Olivia Bell Photography/Getty Images; 6, Africa Studio/Shutterstock; 7, stocknshares/Getty Images; 8, Heike Odermatt/Minden Pictures/Getty Images; 9, balounm/Shutterstock; 10, Dean Pennala/Shutterstock; 11, Amy Johansson/Shutterstock; 12, buchsammy/Getty Images; 13, fotohunter/Shutterstock; 14, Olha Afanasieva/Shutterstock; 15, haveseen/Getty Images; 16, Mike Danneman/Getty Images; 17, JaroPienza/Shutterstock; 18, Alexey V Smirnov/Shutterstock; 19, Luiz Celso Meissner Baptista/EyeEm/Getty Images; 20, Andrew Mayovskyy/Shutterstock; 21, Kseniya Abramova/Getty Images; 22, Volodymyr Goinyk/Shutterstock; 23, Slow Images/Getty Images; 24, Alex Saberi/National Geographic Creative; 25, Design Pics/Carson Ganci/Getty Images; 26, Skip Moody - Rainbow/Getty Images; 27, Project with vigour/Aflo/Getty Images; 28, Maria Zarichnaya/Shutterstock; 29, kavram/Shutterstock; 30, doomu/Shutterstock; 31, Diane Cook and Len Jenshel/National Geographic Creative.

Credits page, Rynio Productions/Shutterstock.

21, Maxim Sosedov/Shutterstock; 22, mikroman6/Getty Images; 23, Frans Lanting/National Geographic Creative; 24, bridge99/Getty Images; 25, nito/Shutterstock; 26, Thomas Ozanne/Getty Images; 27, Yiannis Papadimitriou/Shutterstock; 28, Sondra Paulson/Getty Images; 29, Robsonphoto/Shutterstock; 30, Eduardo Rivero/Shutterstock.

MAY

(Opener), Caiaimage/Andy Roberts/Getty Images; 1, worradirek/Shutterstock; 2, slhy/Shutterstock; 3, DNY59/Getty Images; 4, Africa Studio/Shutterstock; 5, Maria Jeffs/Shutterstock; 6, PSno7/Shutterstock; 7, Vilor/Shutterstock; 8, Vastram/Shutterstock; 9, Heaven's Gift xxx89/Getty Images; 10, Gavran333/Shutterstock; 11, Anna M/Getty Images; 12, Valentyn Volkov/Shutterstock; 13, Darrell Gulin/Getty Images; 14, Iani barbitta/Getty Images; 15, Funkystock/Getty Images; 16, O. Joy …Following my bliss/Getty Images; 17, Distrikt 3/Shutterstock; 18, anthony heflin/Shutterstock; 19, Robby Fakhriannur/Shutterstock; 20, jankovoy/Getty Images; 21, Gary John Norman/Getty Images; 22, Phillip Bartlett/Getty Images; 23, woottigon/Shutterstock; 24, Sandra Caldwell/Shutterstock; 25, Anna-Mari West/Shutterstock; 26, kurdistan/Shutterstock; 27, melis/Shutterstock; 28, Natural at it's best./Getty Images; 29, Kata Ribanszky/Getty Images; 30, RyanKing999/Getty Images; 31, Daisy Gilardini/Getty Images.

JUNE

(Opener), Tomas Sereda/Getty Images; 1, Nga Nguyen/Getty Images; 2, jpique/Getty Images; 3, ultimathule/Shutterstock; 4, Matt Propert; 5, Alexander Ishchenko/Shutterstock; 6, Allkindza/Getty Images; 7, erniedecker/Getty Images; 8, foryouinf/Shutterstock; 9, cdrin/Shutterstock; 10, Kuttelvaserova Stuchelova/Shutterstock; 11, JacobH/Getty Images; 12, narcisa/Getty Images; 13, sevenke/Shutterstock; 14, Sarah Robertson; imagebearersphotography.com/Getty Images; 15, Matej Kastelic/Shutterstock; 16, Boris Sosnovyy/Shutterstock; 17, Mauricio Handler/Getty Images; 18, apinunrin/Shutterstock; 19, Carlos Goldin/Corbis; 20, Josef Friedhuber/Getty Images; 21, leisuretime70/Shutterstock; 22, Perfect Lazybones/Shutterstock; 23, tonda/Getty Images; 24, Africa Studio/Shutterstock; 25, Hintau Aliaksei/Shutterstock; 26, Mizuri/Shutterstock; 27, Renzo Mancini/Getty Images; 28, Triff/Shutterstock; 29, Dan Wang/Getty Images; 30, LiliGraphie/Shutterstock.

JULY

(Opener), Kathy Collins/Getty Images; 1, Steve McCurry; 2, J. Bicking/Shutterstock; 3, PK.pawaris/Shutterstock; 4, Ursula Alter/Getty Images; 5, dugdax/Shutterstock; 6, Axel Ellerhorst/Getty Images; 7, elena moiseeva/Shutterstock; 8, ehaurylik/Getty Images; 9, Mint Images/Art Wolfe/Getty Images; 10, Ondrej Prosicky/Shutterstock; 11, Creative Travel Projects/Shutterstock; 12, Tanya Puntti/Shutterstock; 13, Mark Walrave/EyeEm/Getty Images; 14, Africa Studio/Shutterstock; 15, ronnybas/Shutterstock; 16, mikroman6/Getty Images; 17, mbbirdy/Getty Images; 18, B.and E. Dudzinscy/Shutterstock; 19, Steve Terrill/Corbis; 20, irisphoto2/Getty Images; 21, Anna Hoychuk/Shutterstock; 22, Mike Theiss/Getty Images; 23, Tish1/Shutterstock; 24, vuk8691/Getty Images; 25, Vishwanath Bhat/Getty Images; 26, Melinda Moore/Getty Images; 27, Dave Allen Photography/Getty Images; 28, Uliana Bazar; 29, RTimages/Shutterstock; 30, Sidarta/Shutterstock; 31, Giancarlo Liguori/Shutterstock.

AUGUST

(Opener), Pham Ty; 1, Borislav Borisov/Shutterstock; 2, harmpeti/Shutterstock; 3, Posnov/Getty Images; 4, Colin Anderson/Getty Images; 5, Anton Petrus/Shutterstock; 6, Iraklis Makrigiannakis/National Geographic Your Shot; 7, Mike Powles/Getty Images; 8, Uliana Bazar; 9, Elena Larina/Shutterstock; 10, Mooshny/Shutterstock; 11, Bruce Dale/National Geographic Creative; 12, James Warwick/Getty Images; 13, Michael Nichols/National Geographic Creative; 14, claudiofichera/Shutterstock; 15, Lambert (Bart) Parren/Getty Images; 16, Vadim Petrakov/Shutterstock; 17, Tim Martin/Getty Images; 18, Richard Mitchell - Touching Light Photography/Getty Images; 19, Uliana Bazar; 20, Julia Davila-Lampe/Getty Images; 21, Sandra Caldwell/Shutterstock; 22, Alexandra Jursova/Getty Images; 23, Philippe Sainte-Laudy Photography/Getty Images; 24, hunthomas/Shutterstock; 25, Marta Teron/Shutterstock; 26, Kostenko Maxim/Shutterstock; 27, Rozikassim Photography/Getty Images; 28, blew_i/Getty Images; 29, Keren Su/Getty Images; 30, gezik/Shutterstock; 31, enviromantic/Getty Images.

SEPTEMBER

(Opener), sssss1gmel/Getty Images; 1, Marcin-linfernum/Shutterstock; 2, Thomas J. Abercrombie/National Geographic Creative; 3, David Yarrow Photography/Getty Images; 4, Dirk Ercken/Shutterstock; 5, Panos Karas/Shutterstock;

ILLUSTRATIONS CREDITS

Cover, haraldmuc/Shutterstock; Back cover, Elenadesign/Shutterstock (LE), DanielPrudek/Getty Images (CTR), irisphoto2/Getty Images (RT); Half title page, AVprophoto/Shutterstock; Title page, Prasit Chansareekorn/Getty Images; Table of Contents, Nattika/Shutterstock.

JANUARY

(Opener), SIME/eStock Photo; 1, Borut Trdina/Getty Images; 2, Anurak Pongpatimet/Shutterstock; 3, Africa Studio/Shutterstock; 4, Cultura RM Exclusive/Philip Lee Harvey/Getty Images; 5, Chantal de Bruijne/Shutterstock; 6, Tom Stoddart/Getty Images; 7, Sergejs Razvodovskis/Getty Images; 8, Willyam Bradberry/Shutterstock; 9, MarcelC/Getty Images; 10, Multi-bits/Getty Images; 11, Neil Holmes/Getty Images; 12, Danita Delimont/Getty Images; 13, Ron and Patty Thomas Photography/Getty Images; 14, Samere Fahim Photography/Getty Images; 15, Africa Studio/Shutterstock; 16, Maxim Khytra/Shutterstock; 17, szefei/Shutterstock; 18, Shulevskyy Volodymyr/Shutterstock; 19, StudioSmart/Shutterstock; 20, elenaleonova/Getty Images; 21, NatashaBreen/Getty Images; 22, zroakez/Getty Images; 23, KPG_Payless/Shutterstock; 24, Maminau Mikalai/Shutterstock; 25, Tetra Images/Getty Images; 26, jaredkay/Getty Images; 27, eyal granith/Shutterstock; 28, stevecoleimages/Getty Images; 29, H. Armstrong Roberts/ClassicStock/Getty Images; 30, gadag/Shutterstock; 31, Nicram Sabod/Shutterstock.

FEBRUARY

(Opener), Kevin Day/Shutterstock; 1, LiliGraphie/Getty Images; 2, Yuri Dojc/Getty Images; 3, Anna Omelchenko/Shutterstock; 4, Lev Kropotov/Shutterstock; 5, Michael Blann/Getty Images; 6, 06photo/Getty Images; 7, Monthon Wa/Getty Images; 8, Mother Daughter Press/Getty Images; 9, StevenRussellSmithPhotos/Shutterstock; 10, Elenadesign/Shutterstock; 11, David Nunuk/Science Source; 12, Westend61/Getty Images; 13, Tyson Fisher/National Geographic Your Shot; 14, Tania Zbrodko/Shutterstock; 15, Peter Svetoslavov/Shutterstock; 16, Mikhail hoboton Popov/Shutterstock; 17, MongPro/Shutterstock; 18, Martin M303/Shutterstock; 19,

SIME/eStock Photo; 20, Subbotina Anna/Shutterstock; 21, Rawpixel.com/Shutterstock; 22, Tiina & Geir/Getty Images; 23, Vladimir Nikulin/Getty Images; 24, Sally Anscombe/Getty Images; 25, EHStock/Getty Images; 26, Layne Kennedy/National Geographic Your Shot; 27, RayTango/Getty Images; 28-29, Tony Hallas/Getty Images.

MARCH

(Opener), Comstock/Getty Images; 1, Pushish Images/Shutterstock; 2, Francesco Chiesa/Shutterstock; 3, Elias Kordelakos/Shutterstock; 4, pixelklex/Shutterstock; 5, Lorcel/Shutterstock; 6, Marcin-linfernum/Shutterstock; 7, Merydolla/Shutterstock; 8, Natalia Bratslavsky/Shutterstock; 9, 68/Ocean/Corbis; 10, hanhanpeggy/Getty Images; 11, Thomas Zsebok/Shutterstock; 12, Marie C Fields/Shutterstock; 13, A. and I. Kruk/Shutterstock; 14, Frans Lanting/National Geographic Creative; 15, Schweinepriester/Shutterstock; 16, Sergieiev/Shutterstock; 17, James P. Blair/National Geographic Creative; 18, YinYang/Getty Images; 19, Inna Skibinsky/National Geographic Your Shot; 20, Mike Hill/Getty Images; 21, Oleksiy Mark/Shutterstock; 22, jared ropelato/Shutterstock; 23, sergijn/Shutterstock; 24, Cultura RM/Lottie Davies/Getty Images; 25, Sergei Reoutov/National Geographic Your Shot; 26, DAJ/Getty Images; 27, Frans Lemmens/Getty Images; 28, Marco Uliana/Shutterstock; 29, Irina Tischenko/Shutterstock; 30, Elena-studio/Getty Images; 31, Sunny studio/Shutterstock.

APRIL

(Opener), YinYang/Getty Images; 1, ROMAOSLO/Getty Images; 2, RapidEye/Getty Images; 3, Muskoka Stock Photos/Shutterstock; 4, Bildagentur Zoonar GmbH/Shutterstock; 5, Uliana Bazar; 6, Scisetti Alfio/Shutterstock; 7, ronnybas/Shutterstock; 8, 7Michael/Getty Images; 9, Serjio74/Shutterstock; 10, Tatiana Popova/Shutterstock; 11, Daniel H. Bailey/Getty Images; 12, olaf herschbach/Getty Images; 13, Alena Root/Getty Images; 14, Robert Hoetink/Shutterstock; 15, XiXinXing/Getty Images; 16, Charles Krebs/Getty Images; 17, SarahSallySpear/Getty Images; 18, morganlane/Shutterstock; 19, tarras/Shutterstock; 20, Irina Ovchinnikova/Shutterstock;

Stoppard, Tom
b. 1937
British playwright and
screenwriter

Strayed, Cheryl
b. 1968
American author

Swetchine, Anne-Sophie
1782–1857
Russian author
and mystic

T

Tagore, Rabindranath
1861–1941
Bengali poet, novelist,
essayist, and composer

Tartt, Donna
b. 1963
American author

**Teresa, Mother (Agnes
Gonxha Bojaxhiu)**
1910–1997
Albanian-Indian nun
and religious leader

Teresa of Ávila
1515–1582
Spanish nun

Thompson, Hunter S.
1937–2005
American journalist
and author

Thoreau, Henry David
1817–1862
American author, poet,
and philosopher

Thurber, James
1894–1961
American cartoonist
and humorist

Tolle, Eckhart
b. 1948
German spiritual teacher
and writer

Tolstoy, Leo
1828–1910
Russian novelist and
short-story writer

Traherne, Thomas
1636–1674
English poet and clergyman

U

Updike, John
1932–2009
American novelist,
poet, and critic

V

**Virgil (Publius Vergilius
Maro)**
70–19 B.C.
Roman poet

Vonnegut, Kurt
1922–2007
American writer

W

Walker, Alice
b. 1944
American novelist,
poet, and activist

Wallace, Lew (Lewis)
1827–1905
American author
and lawyer

**Watterson, Bill
(William Boyd II)**
b. 1958
American cartoonist
and author

Weil, Simone
1909–1943
French philosopher
and social activist

Weiner, Jennifer
b. 1970
American writer

Welty, Eudora
1909–2001
American author

West, Cornel
b. 1953
American author
and activist

West, Rebecca
1892–1983
British author and
journalist

**Wharton, Edith
Newbold Jones**
1862–1937
American novelist

Whitman, Walt
1819–1892
American poet, essayist,
and journalist

Wiesel, Elie
b. 1928
Jewish writer, activist,
and Nobel Laureate

Wilde, Oscar
1854–1900
Irish novelist
and dramatist

Williams, Margery
1881–1944
English author

Williamson, Marianne
b. 1952
American spiritual writer
and poet

Windsor, Edie (Edith)
b. 1929
LGBT activist

Winfrey, Oprah
b. 1954
American media
personality

Woolf, Virginia (Adeline)
1882–1941
British novelist and
essayist

Y

Young, William Paul
b. 1955
Canadian author

Ono, Yoko
b. 1933
Japanese artist
and activist

Ovid (Publius Ovidius Naso)
43 B.C.–A.D. 17
Roman poet

P

Palahniuk, Chuck
b. 1962
American novelist

Parton, Dolly
b. 1946
American singer-songwriter

Pascal, Blaise
1623–1662
French mathematician, philosopher, and writer

Patchett, Ann
b. 1963
American author

Phillpotts, Eden
1862–1960
English author, poet, and dramatist

Picoult, Jodi
b. 1966
American author

Pirsig, Robert M.
b. 1928
American writer and philosopher

Plath, Sylvia
1932–1963
American poet, novelist, and short-story writer

Plato
428–348 B.C.
Ancient Greek philosopher

Poehler, Amy Meredith
b. 1971
American actress, comedian, and author

Pope, Alexander
1688–1744
English poet

Priestley, J. B. (John Boynton)
1894–1984
English author, playwright, and broadcaster

Proust, Marcel
1871–1922
French novelist

Q

Quindlen, Anna
b. 1953
American journalist and novelist

R

Rand, Ayn
1905–1982
American novelist

Rawlings, Marjorie Kinnan
1896–1953
American author

Rilke, Rainer Maria
1875–1926
Bohemian-Austrian poet

Rochefoucauld, François VI, Duc de La
1613–1680
French author

Rogers, Frederick McFeely
1928–2003
American educator and television personality

Rowling, J. K. (Joanne Kathleen)
b. 1965
British novelist

Rumi (Jalal ad-Din ar-Rumi)
1207–1273
Persian poet

Russell, Bertrand
1872–1970
British philosopher, mathematician, and social critic

Russell, Lady Rachel
1636–1723
English author

S

Sagan, Carl
1934–1996
American astronomer, astrophysicist, and author

Saint-Exupéry, Antoine de
1900–1944
French writer, poet, and aviator

Salzberg, Sharon
b. 1952
American author and teacher

Sand, George (Amandine-Aurore-Lucile Dupin)
1804–1876
French novelist and memoirist

Sappho
ca 700 B.C.
Greek poet

Sedaris, David
b. 1956
American humor writer

Shakespeare, William
1564–1616
British playwright and poet

Shaw, George Bernard
1856–1950
Irish playwright

Smith, Zadie
b. 1975
English author

Snicket, Lemony (Daniel Handler)
b. 1970
American author

Sontag, Susan
1933–2004
American writer and teacher

Sophocles
497–406 B.C.
Greek playwright

Sparks, Nicholas
b. 1965
American writer and novelist

Staël, Germaine de
1776–1817
French-Swiss author

Stein, Gertrude
1874–1946
American novelist and poet

Steinbeck, John
1902–1968
American novelist

Krakauer, Jon
b. 1954
American writer

Krauss, Nicole
b. 1974
American author

Kundera, Milan
b. 1929
Czech writer

L

La Fontaine, Jean de
1621–1695
French poet

Lamb, Charles
1775–1834
British essayist
and author

Lamott, Anne
b. 1954
American novelist and
nonfiction writer

Lao-tzu
604–531 B.C.
Chinese philosopher

Larsson, Stieg
1954–2004
Swedish writer and
journalist

Lawrence, D. H.
(David Herbert)
1885–1930
English novelist

Lee, Harper
1926–2016
American novelist

L'Engle, Madeleine
1918–2007
American writer

Le Guin, Ursula K.
b. 1929
American novelist, poet,
and essayist

Lespinasse, Julie-
Jeanne-Éléonore de
1732–1776
French writer

Lessing, Doris
1919–2013
British novelist and poet

Levin, Nancy
b. 1965
American author

Lewis, C. S. (Clive
Staples)
1898–1963
British novelist, essayist,
and theologian

Lindbergh, Anne
Morrow
1906–2001
American writer, poet,
and aviator

Lockhart, E. (Emily
Jenkins)
b. 1967
American writer

M

MacDonald, George
1824–1905
Scottish novelist, poet,
and minister

Marion, Isaac
b. 1981
American writer

Martel, Yann
b. 1963
Canadian author

Maslow, Abraham
1908–1970
American psychologist

Maugham, W. Somerset
(William)
1874–1965
British playwright
and writer

Merton, Thomas
1915–1968
American writer

Miller, Henry
1891–1980
American novelist

Milne, A. A. (Alan
Alexander)
1882–1956
English novelist, poet,
and playwright

Mitchell, David
b. 1969
English novelist

Mitchell, Margaret
1900–1949
American novelist

Molière (Jean-Baptiste
Poquelin)
1622–1673
French playwright
and actor

Montaigne, Michel de
1533–1592
French writer and
philosopher

Morrison, Toni (Chloe
Ardelia Wofford)
b. 1931
American novelist and poet

Müller, Friedrich Max
1823–1900
German scholar

Munro, Alice
b. 1931
Canadian author

Murakami, Haruki
b. 1949
Japanese writer

Murdoch, Iris
1919–1999
British novelist
and philosopher

N

Naylor, Gloria
b. 1950
African-American novelist
and educator

Neruda, Pablo
1904–1973
Chilean poet, diplomat,
and politician

Nicholls, David
b. 1966
English author
and screenwriter

Nin, Anaïs
1903–1977
French diarist
and novelist

O

O'Donohue, John
1956–2008
Irish poet, philosopher,
and Catholic scholar

O'Keeffe, Georgia
1887–1986
American artist

Oliver, Mary
b. 1935
American poet

Gilchrist, Ellen
b. 1935
American writer

Giovanni, Nikki (Yolande Cornelia)
b. 1943
American poet

Goethe, Johann Wolfgang von
1749–1832
German novelist, poet, playwright, and philosopher

Gogh, Vincent van
1853–1890
Dutch painter

Goldman, William
b. 1931
American novelist, playwright, and screenwriter

Goodall, Jane
b. 1934
British primatologist and anthropologist

Goodman, Ellen
b. 1941
American journalist

Green, John
b. 1977
American author

Guo, Xiaolu
b. 1973
Chinese novelist and filmmaker

H

Hadewijch of Brabant
1220–1260
Flemish Beguine poet and mystic

Hafez (Šams-al-Din Moḥammad, of Shiraz)
1315–1390
Persian poet

Hanh, Thich Nhat
b. 1926
Vietnamese Buddhist monk, poet, author, and activist

Hansberry, Lorraine
1930–1965
American playwright and writer

Hegel, Georg Wilhelm Friedrich
1770–1831
German philosopher

Hemingway, Ernest
1899–1961
American author and journalist

Henry, O. (William Sydney Porter)
1862–1910
American writer

Henson, Jim
1936–1990
American puppeteer and creator of the Muppets

Hepburn, Audrey
1929–1993
Actress and philanthropist

Hepburn, Katharine
1907–2003
American actress

Hinckley, Gordon B. (Bitner)
1910–2008
American LDS Church president

Holmes, Oliver Wendell, Sr.
1809–1894
American physician, professor, and author

Holmes, Reginald Vincent
1896–unknown
American poet and author

Hubbard, Elbert
1856–1915
American writer and editor

Hughes, Ted
1930–1998
English poet

Hugo, Victor
1802–1885
French poet, novelist, and dramatist

Hurston, Zora Neale
1891–1960
American novelist, essayist, and folklorist

Huxley, Aldous (Leonard)
1894–1963
British novelist, playwright, and satirist

I

Irving, John
b. 1942
American novelist and screenwriter

J

James, Henry
1843–1916
American-born British writer

Jobs, Steve (Steven Paul)
1955–2011
American entrepreneur and co-founder of Apple Inc.

Jong, Erica
b. 1942
American novelist

Jung, Carl (Gustav)
1875–1961
Swiss psychiatrist and founder of analytical psychology

K

Kenmore, Carolyn
b. 1944
American model and author

Kennedy, John Fitzgerald
1917–1963
American president

Kerouac, Jack
1922–1969
American novelist and poet

Kidd, Sue Monk
b. 1948
American writer

Kierkegaard, Søren
1813–1855
Danish philosopher, theologian, and writer

King, Stephen
b. 1947
American novelist

Kingsolver, Barbara
b. 1955
American novelist, poet, and essayist

Chavez, Cesar
1927–1993
American activist

Chbosky, Stephen
b. 1970
American author
and director

Chekhov, Anton
1860–1904
Russian author

Chödrön, Pema (Deirdre Blomfield-Brown)
b. 1936
American teacher,
author, and Tibetan
Buddhist nun

Chopra, Deepak
b. 1947
Indian medical doctor
and spiritual writer

Coelho, Paulo
b. 1947
Brazilian novelist
and lyricist

Confucius
551–479 B.C.
Chinese philosopher
and teacher

D

Dahl, Roald
1916–1990
British novelist, short-
story writer, and
screenwriter

Dalai Lama XIV (Lhamo Dondrub)
b. 1935
Tibetan Buddhist
head monk

Díaz, Junot
b. 1968
Dominican-American
writer and professor

Dickens, Charles
1812–1870
English writer and
social critic

Didion, Joan
b. 1934
American journalist
and novelist

Dillard, Annie
b. 1945
American poet, essayist,
and literary critic

Drummond, Henry
1851–1897
Scottish evangelist
and writer

Dunham, Lena
b. 1986
American actress, writer,
and screenwriter

E

Ebner-Eschenbach, Marie von
1830–1916
Austrian writer

Eliot, George (Mary Anne Evans)
1819–1880
British novelist

Eliot, T. S. (Thomas Stearns)
1888–1965
Poet and playwright

Ellis, Albert
1913–2007
American psychologist

Emerson, Ralph Waldo
1803–1882
American essayist,
lecturer, and poet

Ende, Michael
1929–1995
German author

Ephron, Nora
1941–2012
American screenwriter,
producer, and journalist

Erdrich, Louise
b. 1954
Native American writer

Euripides
480–406 B.C.
Greek playwright
and poet

F

Faulkner, William
1897–1962
American writer

Fielding, Helen
b. 1958
English novelist
and screenwriter

Fitzgerald, F. Scott (Francis Scott Key)
1896–1940
American author

Fitzgerald, Zelda
1900–1948
American novelist

Flaubert, Gustave
1821–1880
French novelist

Foer, Jonathan Safran
b. 1977
American writer

Forster, E. M. (Edward Morgan)
1879–1970
British novelist, essayist,
and critic

Franzen, Jonathan
b. 1959
American author

Freud, Sigmund
1856–1939
Austrian neurologist and
father of psychoanalysis

Fromm, Erich
1900–1980
German-American
social psychologist and
psychoanalyst

Fuller, Buckminster
1895–1983
American architect,
inventor, and philosopher

G

Gabaldon, Diana
b. 1952
American author

Gaiman, Neil Richard MacKinnon
b. 1960
English author

Gibran, Kahlil
1883–1931
Lebanese-American
artist, poet, writer,
and philosopher

Giffin, Emily
b. 1972
American author

Gilbert, Elizabeth
b. 1969
American writer

CONTRIBUTOR INDEX

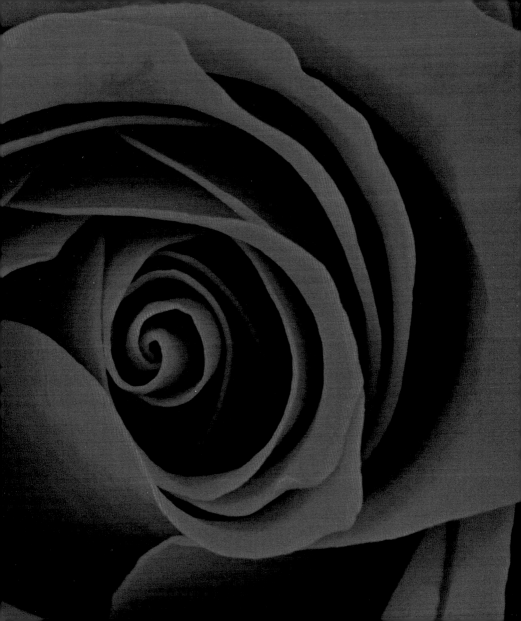

CREDITS

The best people possess a feeling
for beauty, the courage to take risks,
the discipline to tell the truth,
the capacity for sacrifice.

~ ERNEST HEMINGWAY

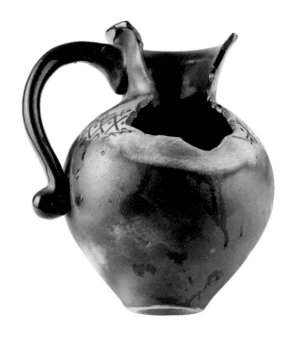

DECEMBER 30

This is a good sign, having a broken heart.
It means we have tried for something.

~ ELIZABETH GILBERT

December 29

One must learn to love, and go through
a good deal of suffering to get to it, and the
journey is always toward the other soul.

~ D. H. Lawrence

It's no trick loving somebody
at their best. Love is loving them
at their worst.

~ TOM STOPPARD, *THE REAL THING*

DECEMBER 27

The hardest thing
on earth is choosing
what matters.

~ SUE MONK KIDD,
THE SECRET LIFE OF BEES

DECEMBER 26

I hope that one day you will have the experience of doing something you do not understand for someone you love.

~ JONATHAN SAFRAN FOER, *EXTREMELY LOUD AND INCREDIBLY CLOSE*

Sometimes when you sacrifice
something precious, you're not really
losing it. You're just passing it
on to someone else.

~ MITCH ALBOM

Love is everything it's cracked up to be . . .
It really is worth fighting for, being brave for,
risking everything for. And the trouble is, if you
don't risk everything, you risk even more.

~ ERICA JONG

December 23

Love is something more stern and
splendid than mere kindness.

~ C. S. Lewis

DECEMBER 22

I have been bent
and broken,
but—I hope—into
a better shape.

~ CHARLES DICKENS,
GREAT EXPECTATIONS

Happiness comes more from loving than
being loved; and often when our affection
seems wounded it is only our vanity bleeding.
To love, and to be hurt often, and to love again—
this is the brave and happy life.

~ J. E. BUCKROSE

DECEMBER 20

If you want the rainbow, you gotta
put up with the rain.

~ DOLLY PARTON

December 19

Even when love isn't enough . . .
somehow it is.

~ Stephen King

It is not how much we do, but how
much love we put in the doing. It is not
how much we give, but how much love
we put in the giving.

~ MOTHER TERESA

DECEMBER 17

Nothing any good isn't hard.

~ F. Scott Fitzgerald

DECEMBER 16

The happiness of love is in action;
its test is what one is willing
to do for others.

~ LEW WALLACE

The best thing to hold onto
in life is each other.

~ AUDREY HEPBURN

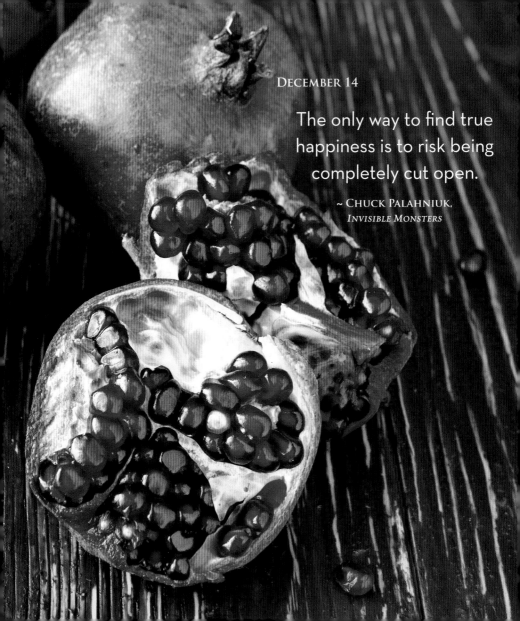

DECEMBER 14

The only way to find true
happiness is to risk being
completely cut open.

~ CHUCK PALAHNIUK,
INVISIBLE MONSTERS

December 13

Real love amounts to withholding the truth,
even when you're offered the perfect
opportunity to hurt someone's feelings.

~ David Sedaris

DECEMBER 12

Part of me believes that love is more
valuable when you have to work for it.

~ AUGUSTEN BURROUGHS

To love is good, too: love being difficult.
For one human being to love another: that is
perhaps the most difficult of all our tasks,
the ultimate, the last test and proof, the work
for which all other work is preparation.

~ RAINER MARIA RILKE

DECEMBER 10

It is when you give
of yourself that
you truly give.

~ Kahlil Gibran

Life can be magnificent and overwhelming—
that is the whole tragedy. Without beauty, love,
or danger it would almost be easy to live.

~ ALBERT CAMUS

DECEMBER 8

Love is divine only and difficult always.

~ TONI MORRISON, *PARADISE*

December 7

Love has nothing to do with what you are expecting to get—only with what you are expecting to give—which is everything.

– Katharine Hepburn

Love . . . is more than three words mumbled before bedtime. Love is sustained by action, a pattern of devotion in the things we do for each other every day.

~ NICHOLAS SPARKS, *The Wedding*

December 5

The sweetest joy,
the wildest woe
is love.

~ Philip James Bailey

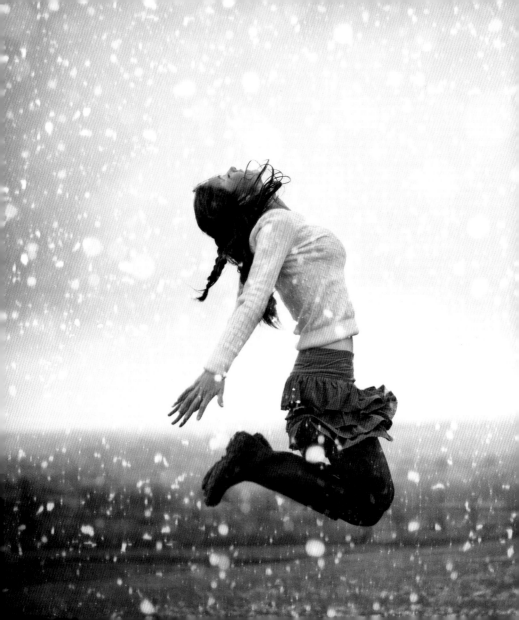

There ain't really no words
for love or pain.

~ GLORIA NAYLOR, *LINDEN HILLS*

DECEMBER 3

The greatest lie ever told about love
is that it sets you free.

~ ZADIE SMITH

December 2

Maybe there's something you're afraid to say,
or someone you're afraid to love, or somewhere
you're afraid to go. It's gonna hurt.
It's gonna hurt because it matters.

~ John Green and David Levithan, *Will Grayson*

December 1

One day, in retrospect, the years
of struggle will strike you as
the most beautiful.

~ Sigmund Freud

DECEMBER

SACRIFICE

But people themselves alter
so much, that there is something new
to be observed in them forever.

~ JANE AUSTEN, *PRIDE AND PREJUDICE*

NOVEMBER 29

If you can learn from hard knocks,
you can also learn from soft touches.

~ CAROLYN KENMORE

NOVEMBER 28

To love oneself is the beginning
of a lifelong romance.

~ OSCAR WILDE

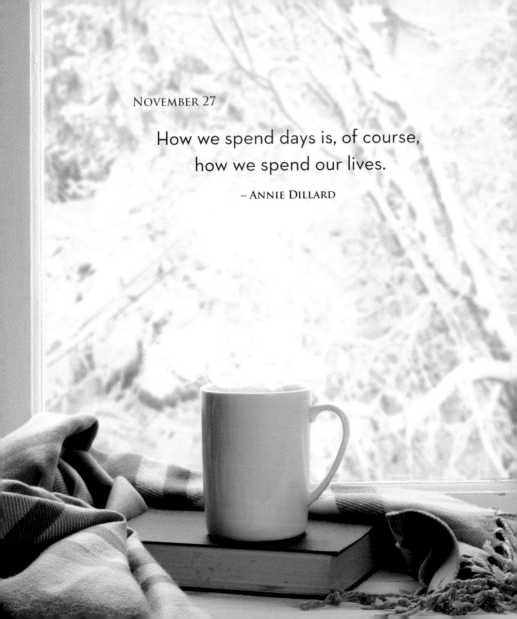

NOVEMBER 27

How we spend days is, of course,
how we spend our lives.

~ ANNIE DILLARD

These are the days that
must happen to you.

~ WALT WHITMAN

The greatest happiness is to transform
one's feelings into actions.

~ Germaine de Staël

NOVEMBER 24

Love is [like the sea.]
It's [a] moving thing,
but still and all, it takes
its shape from
[the] shore it meets,
and it's different
with every shore.

~ ZORA NEALE HURSTON,
THEIR EYES WERE WATCHING GOD

We don't get to choose our own hearts.
We can't make ourselves want what's good for us
or what's good for other people. We don't get
to choose the people we are.

~ DONNA TARTT, *THE GOLDFINCH*

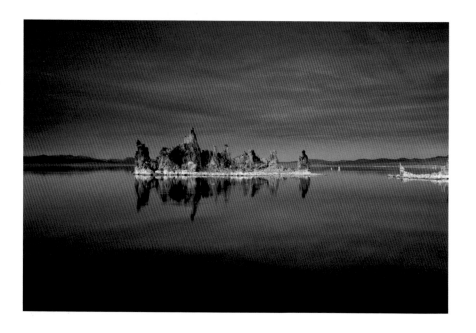

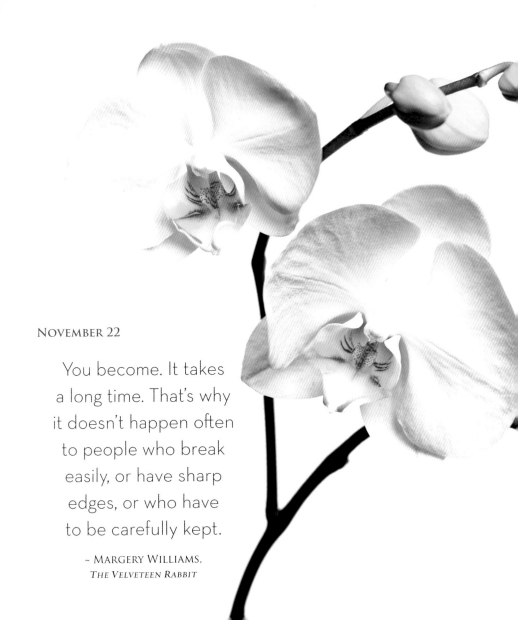

You become. It takes
a long time. That's why
it doesn't happen often
to people who break
easily, or have sharp
edges, or who have
to be carefully kept.

~ MARGERY WILLIAMS,
THE VELVETEEN RABBIT

NOVEMBER 21

Now for some heart work.

~ RAINER MARIA RILKE

When we love, we always strive
to become better than we are.

~ PAULO COELHO, *THE ALCHEMIST*

Love does not begin and end
the way we seem to think it does.
Love is a battle, love is a war;
love is a growing up.

~ JAMES BALDWIN

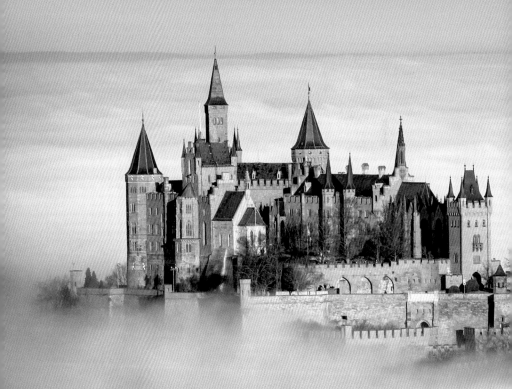

November 18

If you are lucky enough to find
a way of life you love, you have
to find the courage to live it.

~ John Irving

A woman has got to love a bad man
once or twice in her life,
to be thankful for a good one.

~ MARJORIE KINNAN RAWLINGS, *THE YEARLING*

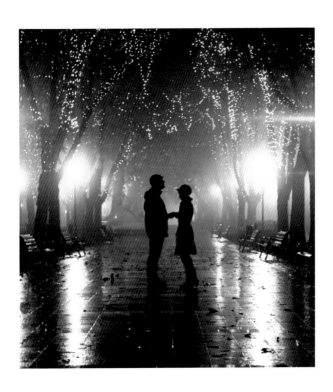

In any given moment we have two options: to step
forward into growth or to step back into safety.

~ ABRAHAM MASLOW

NOVEMBER 15

It is true that those we meet can change us,
sometimes so profoundly that we are not the
same afterwards, even unto our names.

~ YANN MARTEL, *LIFE OF PI*

November 14

Love itself is what is left over when being
in love has burned away, and this is both
an art and a fortunate accident.

~ Louis de Bernières, *Captain Corelli's Mandolin*

You will find as you look back upon your life
that the moments that stand out above
everything else are the moments when you
have done things in the spirit of love.

~ HENRY DRUMMOND

The way you get
meaning into your life
is to devote yourself
to loving others,
devote yourself
to your community
around you, and
devote yourself
to creating something
that gives you purpose
and meaning.

~ MITCH ALBOM

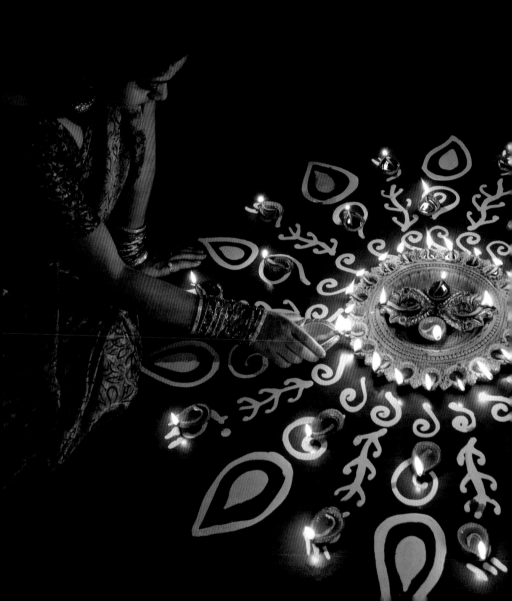

Perhaps the feelings that we experience
when we are in love represent
a normal state. Being in love shows
a person who he should be.

~ ANTON CHEKHOV

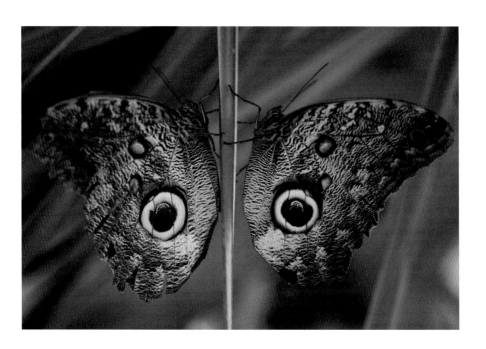

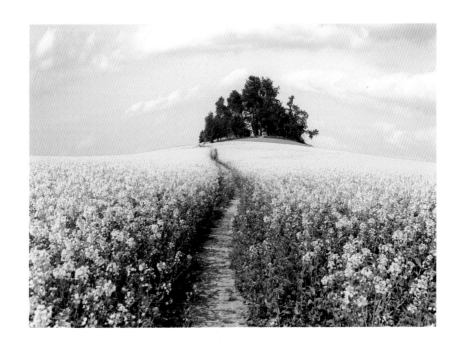

Real love is a pilgrimage. It happens when there is no strategy, but it is very rare because most people are strategists.

~ ANITA BROOKNER

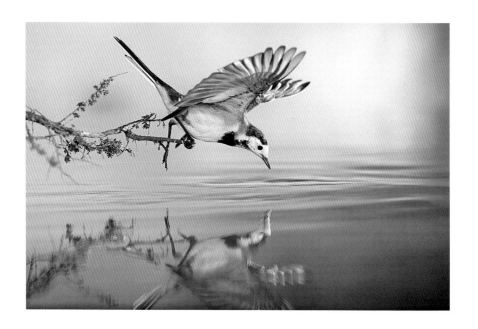

If those whom we begin to love could know us
as we were before meeting them . . . they could
perceive what they have made of us.

~ ALBERT CAMUS

Human relationships don't belong
to engineering, mathematics, chess, which
offer problems that can be perfectly solved.
Human relationships grow, like trees.

~ J. B. PRIESTLEY

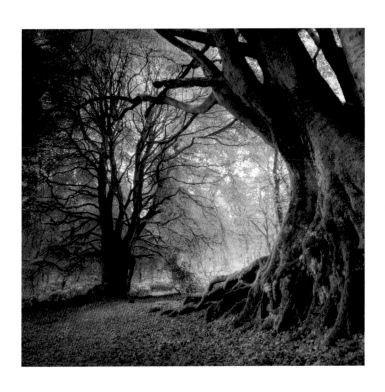

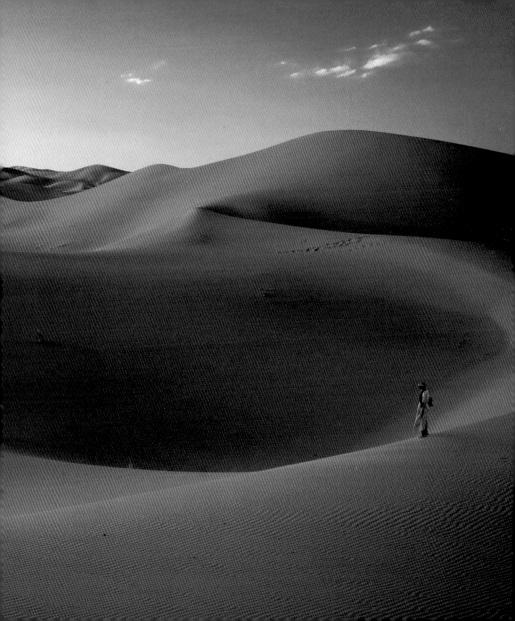

NOVEMBER 7

We do know that no one
gets wise enough
to really understand
the heart of another,
though it is the task
of our life to try.

~ LOUISE ERDRICH

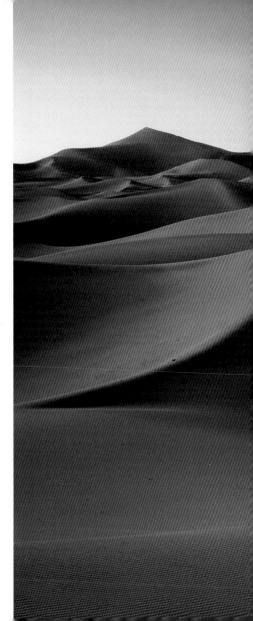

In youth we learn; in age we understand.

~ MARIE VON EBNER ESCHENBACH

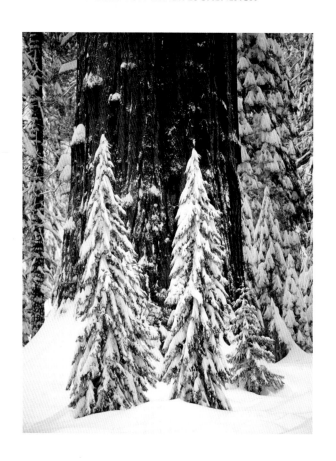

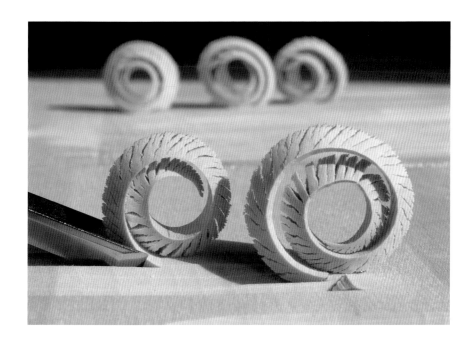

Life isn't about finding yourself.
Life is about creating yourself.

~ GEORGE BERNARD SHAW

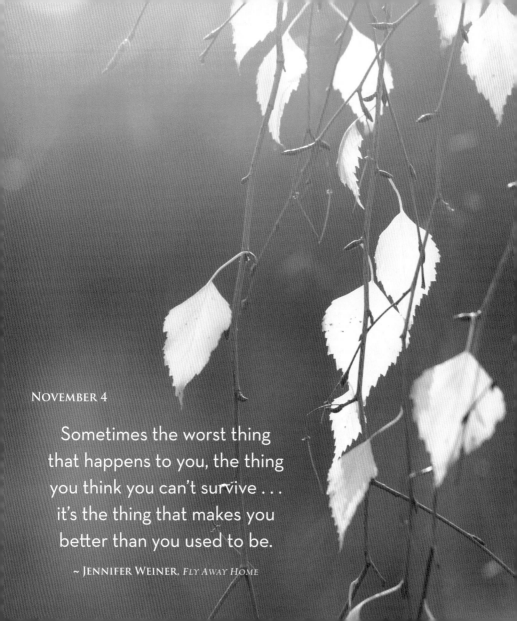

NOVEMBER 4

Sometimes the worst thing
that happens to you, the thing
you think you can't survive . . .
it's the thing that makes you
better than you used to be.

~ JENNIFER WEINER, *FLY AWAY HOME*

Pursue some path, however narrow
and crooked, in which you can walk
with love and reverence.

~ HENRY DAVID THOREAU

Never give up on yourself. Then you will
never give up on others.

~ PEMA CHÖDRÖN

NOVEMBER 1

We accept the love we think we deserve.

~ STEPHEN CHBOSKY, *THE PERKS
OF BEING A WALLFLOWER*

November

GROWTH

True love is not so much a matter of romance
as it is a matter of anxious concern
for the well-being of one's companion.

~ GORDON B. HINCKLEY

When we embark on intimate relationships,
we make a basic human promise to be decent,
to hold a flattering mirror up to each other,
to be respectful as we explore each other.

~ LENA DUNHAM

Never esteem anything as of advantage
to you that will make you break your word
or lose your self-respect.

~ MARCUS AURELIUS

You are built not to shrink down
to less but to blossom into more.

~ OPRAH WINFREY

OCTOBER 27

Two or three things
I know for sure, and
one of them is that
if we are not beautiful
to each other,
we cannot know
beauty in any form.

~ DOROTHY ALLISON

October 26

You attract the right things when you
have a sense of who you are.

~ Amy Poehler

Few people, very few, have a treasure,
and if you do you must hang onto it.
You must not let yourself be waylaid,
and have it taken from you.

~ ALICE MUNRO, *Runaway*

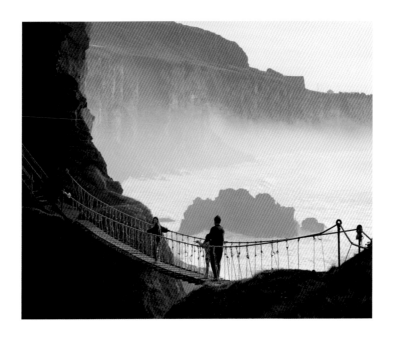

OCTOBER 24

Never say you know the last word
about any human heart.

~ HENRY JAMES

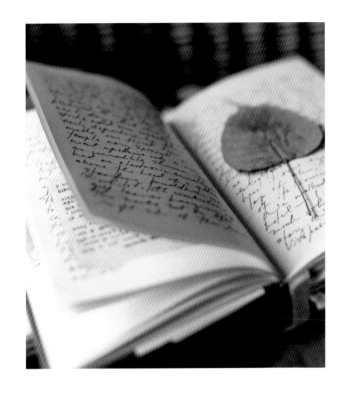

OCTOBER 23

One can never ask anyone
to change a feeling.

~ SUSAN SONTAG

OCTOBER 22

Consideration for
others is the basis
of a good life,
a good society.

~ CONFUCIUS

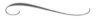

You need someone who will treat you
with respect, love every part of you,
especially your flaws.

~ CECELIA AHERN

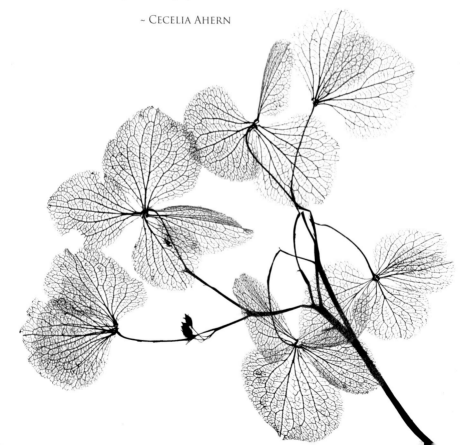

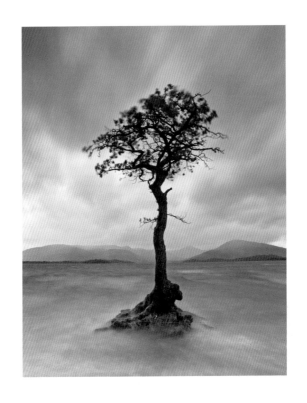

OCTOBER 20

You alone are enough. You have
nothing to prove to anybody.

~ MAYA ANGELOU

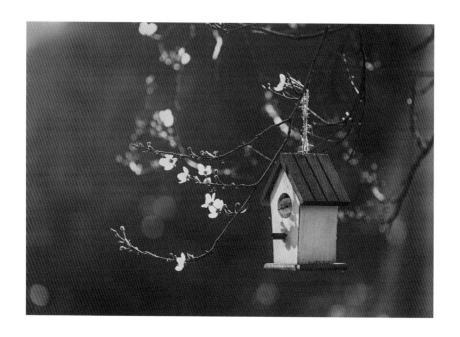

OCTOBER 19

Three things in human life are important:
the first is to be kind; the second is
to be kind; and the third is to be kind.

~ HENRY JAMES

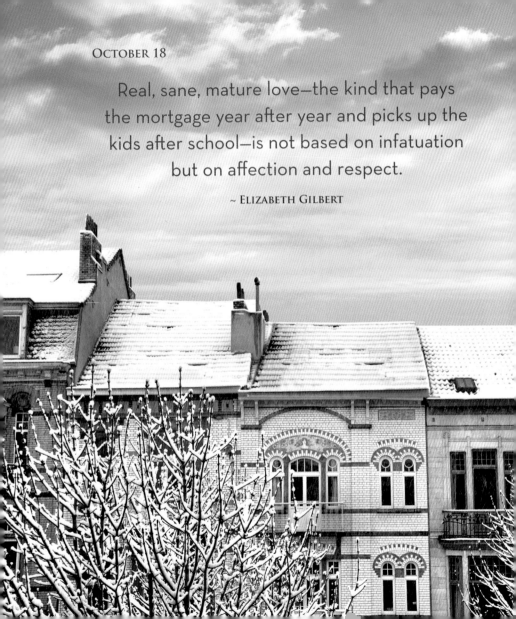

Real, sane, mature love—the kind that pays the mortgage year after year and picks up the kids after school—is not based on infatuation but on affection and respect.

~ ELIZABETH GILBERT

Our chief want in life is someone who
shall make us do what we can.

~ RALPH WALDO EMERSON

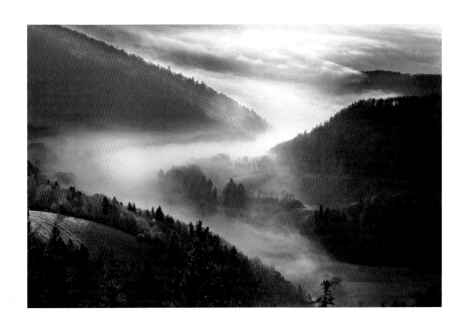

October 16

Love is the expression of the one who loves,
not of the one who is loved. Those who think
they can love only the people they prefer
do not love at all. Love discovers truths
about individuals that others cannot see.

~ Søren Kierkegaard

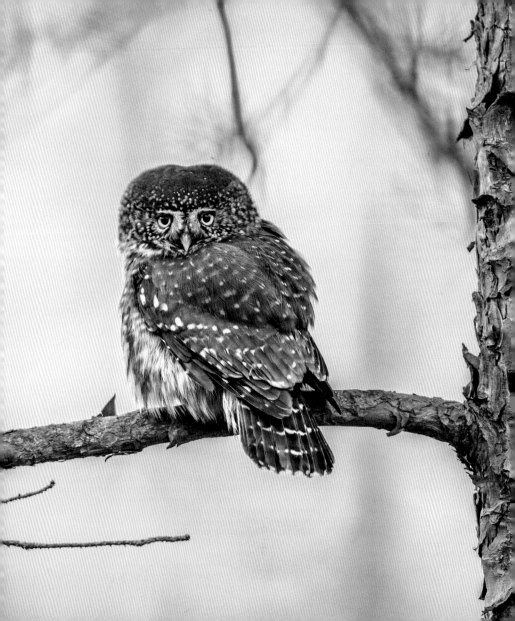

A little Consideration,
a little Thought
for Others, makes
all the difference.

~ A. A. MILNE

Love is about bottomless empathy,
born out of the heart's revelation
that another person is every bit
as real as you are.

~ JONATHAN FRANZEN

OCTOBER 13

Watch out for each other. Love everyone
and forgive everyone, including yourself.
Forgive your anger. Forgive your guilt.
Your shame. Your sadness. Embrace and
open up your love, your joy, your truth,
and most especially your heart.

~ JIM HENSON

OCTOBER 12

Self-love is a part of love just as
self-interest is a part of friendship.

~ GEORGE SAND, *INDIANA*

No need to hurry. No need to sparkle.
No need to be anybody but oneself.

~ VIRGINIA WOOLF

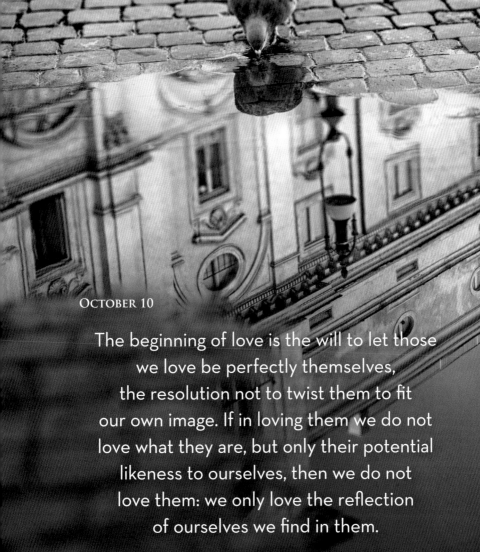

OCTOBER 10

The beginning of love is the will to let those
we love be perfectly themselves,
the resolution not to twist them to fit
our own image. If in loving them we do not
love what they are, but only their potential
likeness to ourselves, then we do not
love them: we only love the reflection
of ourselves we find in them.

~ THOMAS MERTON

If you really care about the quality
of somebody's life as much as you care about
the quality of your own, you have it made.

~ EDIE WINDSOR

October 8

Our lives are not our own. We are bound
to others, past and present, and by each crime
and every kindness, we birth our future.

~ David Mitchell, *Cloud Atlas*

OCTOBER 7

You are your best thing.

~ TONI MORRISON, *Beloved*

You never really understand a person
until you consider things from his point
of view . . . until you climb inside
of his skin and walk around in it.

~ HARPER LEE, *To Kill a Mockingbird*

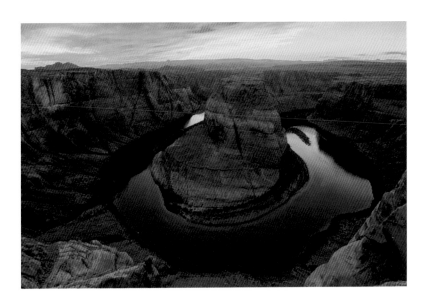

October 5

When we feed
and support our own
happiness, we are
nourishing our ability
to love. That's why
to love means to learn
the art of nourishing
our happiness.

~ Thich Nhat Hanh

To be one, to be united is a great thing.
But to respect the right to be different
is maybe even greater.

~ BONO

OCTOBER 3

Attention is the rarest and
purest form of generosity.

~ SIMONE WEIL

Those who feel lovable, who love,
and who experience belonging simply
believe they are worthy of love
and belonging.

~ BRENÉ BROWN

I always deserve the best treatment
because I never put up with any other.

~ JANE AUSTEN, *EMMA*

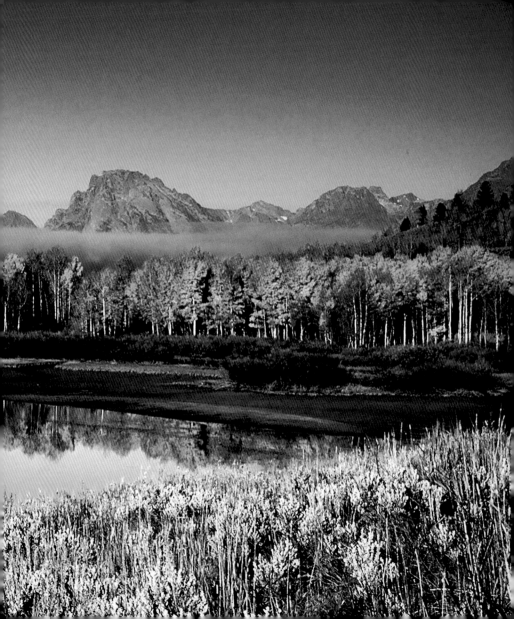

OCTOBER

RESPECT

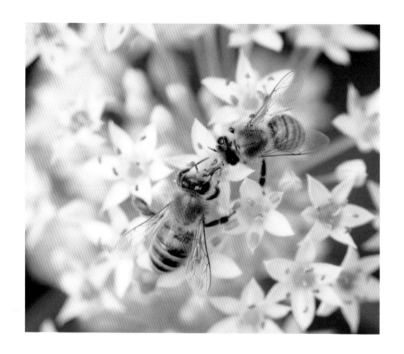

We have to recognize that there cannot be
relationships unless there is commitment,
unless there is loyalty, unless there
is love, patience, persistence.

~ CORNEL WEST

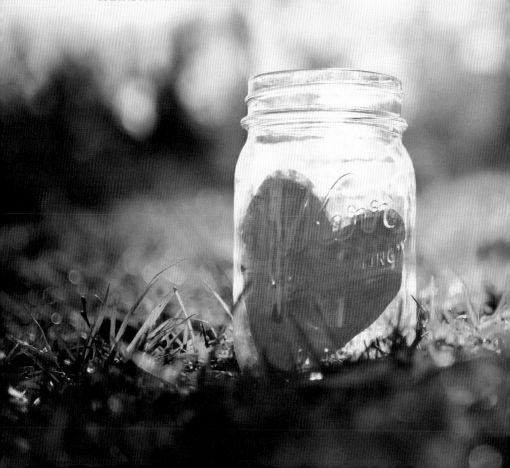

SEPTEMBER 29

Love's gift cannot be given,
it waits to be accepted.

~ RABINDRANATH TAGORE

Love isn't a state of perfect caring.
It is an active noun like struggle.
To love someone is to strive to accept
that person exactly the way he or she is,
right here and now.

~ FRED ROGERS

Patience is always rewarded and
romance is always round the corner!

~ AYN RAND, *THE FOUNTAINHEAD*

SEPTEMBER 26

Be patient toward all that is unsolved
in your heart . . . Live the questions now.
Perhaps you will then gradually,
without noticing it, live along some
distant day into the answer.

~ RAINER MARIA RILKE

Be worthy, love, and love will come.

~ LOUISA MAY ALCOTT, *LITTLE WOMEN*

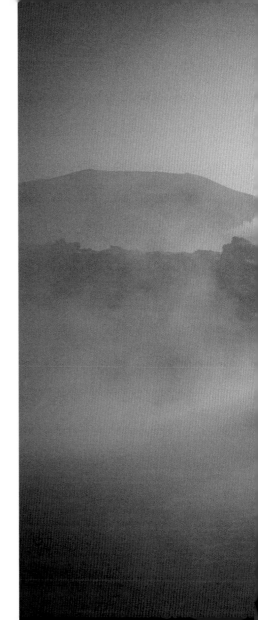

SEPTEMBER 24

On the other side
of pain, there is
still love.

~ MADELEINE L'ENGLE,
A HOUSE LIKE A LOTUS

Love isn't something natural. Rather it
requires discipline, concentration, patience,
faith, and the overcoming of narcissism.
It isn't a feeling, it is a practice.

~ ERICH FROMM

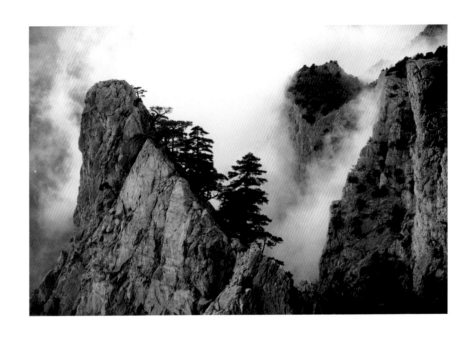

Be still and wait without hope, for hope would
be hope for the wrong thing; wait without love,
for love would be love of the wrong thing;
there is yet faith, but the faith and the love
are all in the waiting.

~ T. S. ELIOT

SEPTEMBER 21

Things come suitable to the time.

~ ENID BAGNOLD

Honor the space between
no longer and not yet.

~ NANCY LEVIN

If you haven't found it yet, keep looking.

~ STEVE JOBS

The course of true love
never did run smooth.

~ WILLIAM SHAKESPEARE,
A MIDSUMMER NIGHT'S DREAM

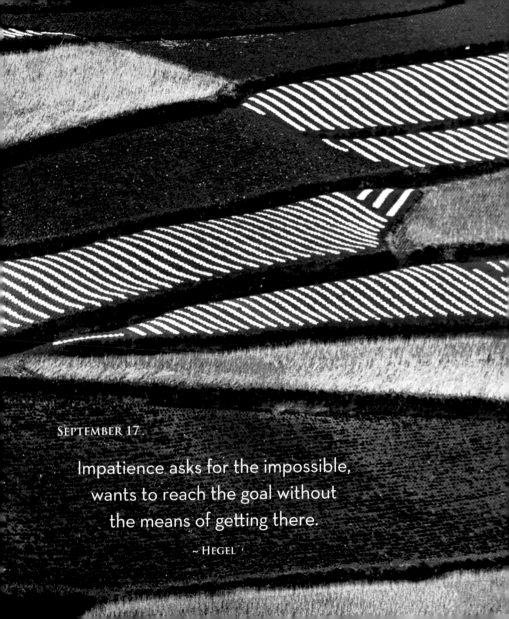

SEPTEMBER 17

Impatience asks for the impossible,
wants to reach the goal without
the means of getting there.

~ HEGEL

The truth is, most of us discover where
we are headed when we arrive.

~ BILL WATTERSON

Everything is hard before it is easy.

~ GOETHE

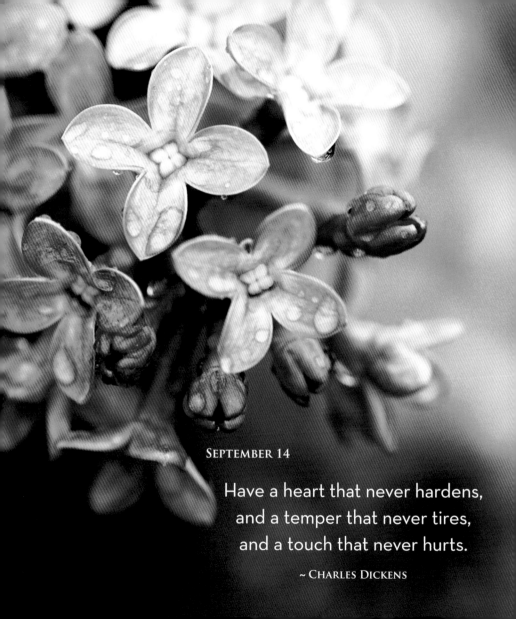

SEPTEMBER 14

Have a heart that never hardens,
and a temper that never tires,
and a touch that never hurts.

~ CHARLES DICKENS

Rivers know this: there is no hurry.
We shall get there some day.

~ A. A. MILNE

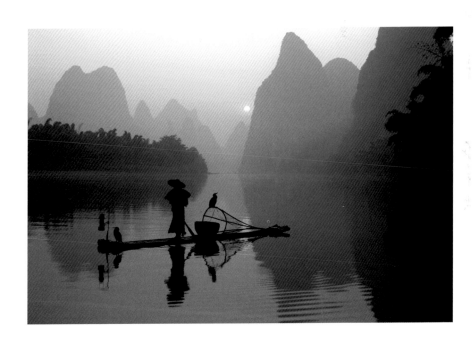

SEPTEMBER 12

Most of the time,
all you have
is the moment,
and the imperfect
love of the people
around you.

~ ANNE LAMOTT

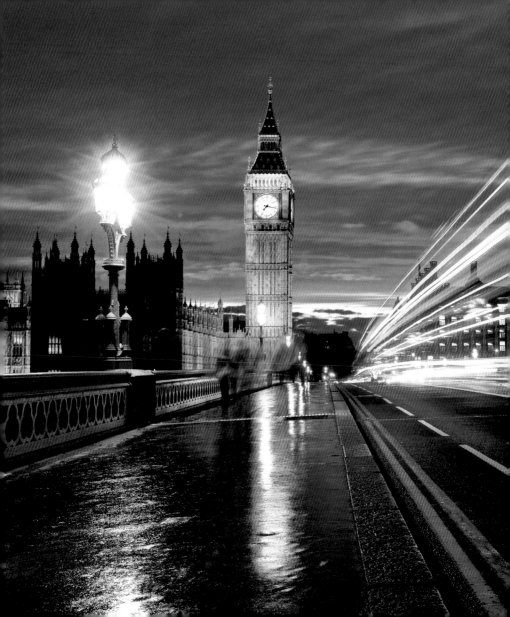

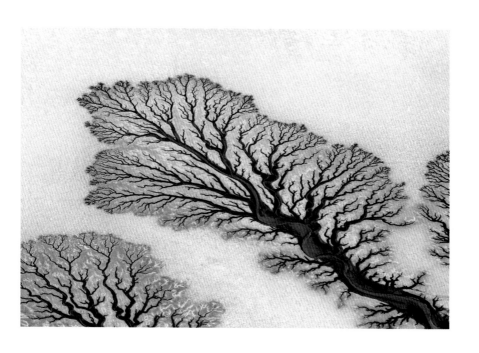

There is not love of life
without despair about life.

~ ALBERT CAMUS

When you love someone you do not
love them, all the time, in the exact
same way, from moment to moment. It is
an impossibility. It is a lie to pretend to.

~ ANNE MORROW LINDBERGH

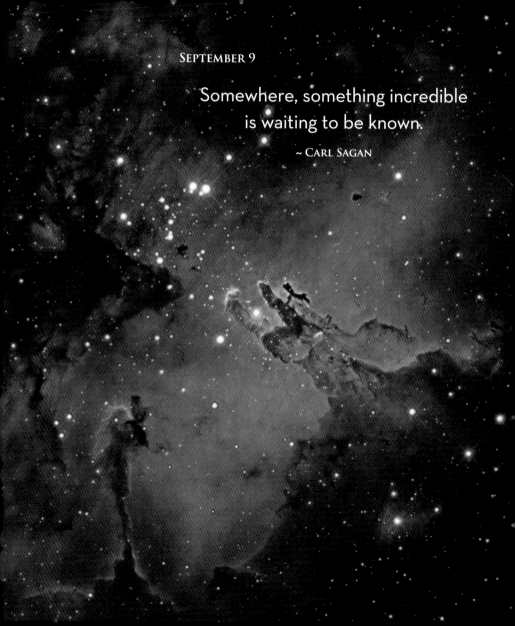

SEPTEMBER 9

Somewhere, something incredible
is waiting to be known.

~ CARL SAGAN

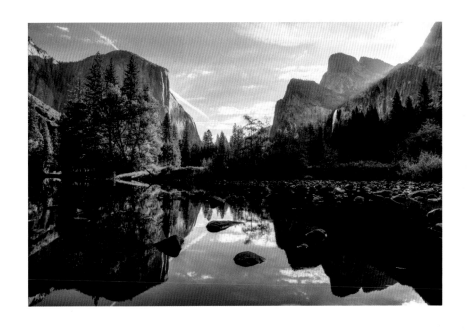

Adopt the pace of nature:
her secret is patience.

~ RALPH WALDO EMERSON

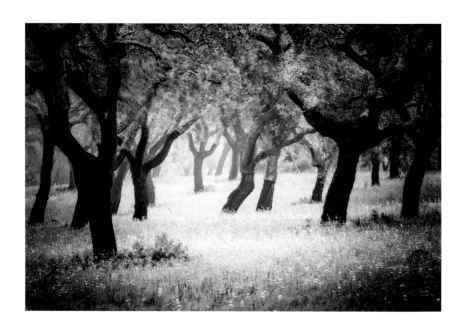

Trees that are slow to grow
bear the best fruit.

~ Molière

Be patient and tough; someday
this pain will be useful to you.

~ OVID

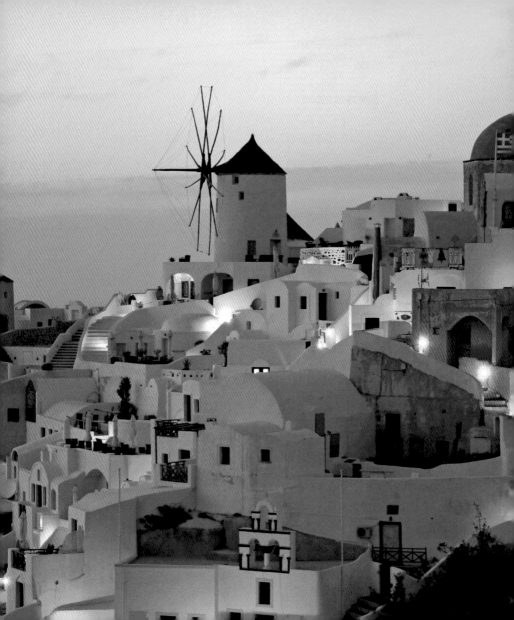

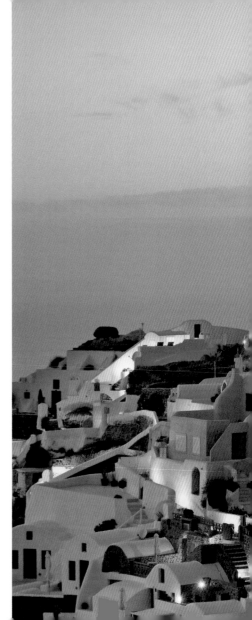

SEPTEMBER 5

Whatever it is
you're seeking
won't come
in the form
you're expecting.

~ HARUKI MURAKAMI

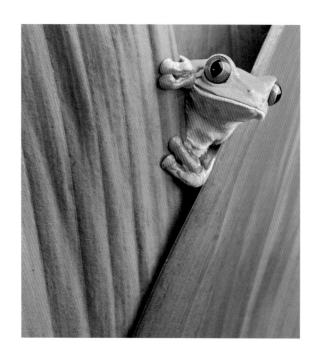

Know your own happiness. You want
nothing but patience—or give it
a more fascinating name, call it hope.

~ JANE AUSTEN

It's a funny thing about life. If you refuse
to settle for anything less than the best,
that's what it will give you.

~ W. Somerset Maugham

We do not need to go out and
find love; rather, we need to
be still and let love discover us.

~ JOHN O'DONOHUE

September 1

That is happiness; to be dissolved
into something complete and great.
When it comes to one, it comes
as naturally as sleep.

~ WILLA CATHER, *My Ántonia*

SEPTEMBER

PATIENCE

AUGUST 31

How we need another soul to cling to.

~ SYLVIA PLATH

We cannot tell the precise moment when
friendship is formed. As in filling a vessel drop
by drop, there is at last a drop which makes it
run over; so in a series of kindnesses there is
at last one which makes the heart run over.

~ RAY BRADBURY, *FAHRENHEIT 451*

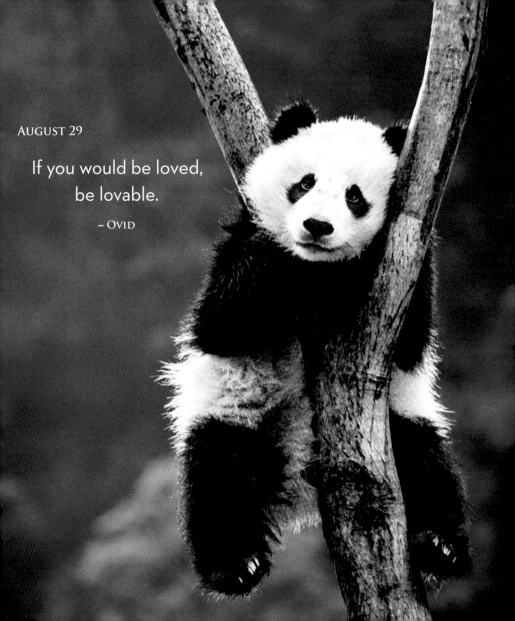

AUGUST 29

If you would be loved,
be lovable.

~ OVID

August 28

There is one friend in the life of each
of us who seems not a separate person,
however dear and beloved, but an expansion,
an interpretation, of one's self, the very
meaning of one's soul.

~ Edith Wharton

AUGUST 27

Each friend represents
a world in us, a world
possibly not born
until they arrive, and it is
only by this meeting that
a new world is born.

~ ANAÏS NIN

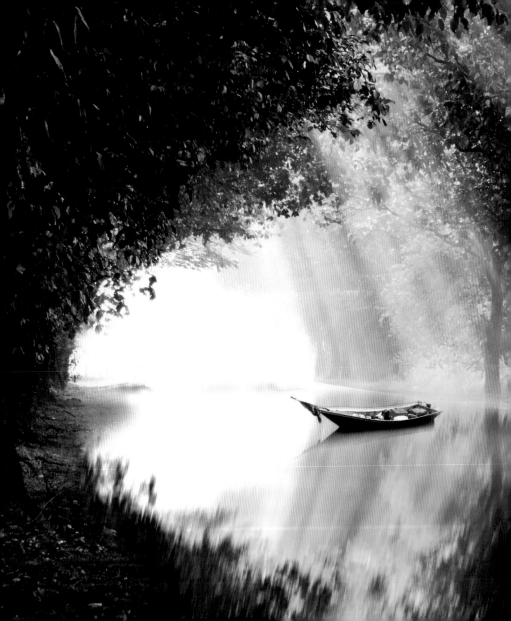

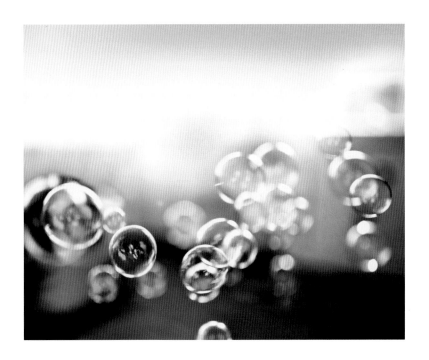

AUGUST 26

A good laugh heals a lot of hurts.

~ MADELEINE L'ENGLE, *A RING OF ENDLESS LIGHT*

Love and friendship. They are
what make us who we are, and what
can change us, if we let them.

~ EMILY GIFFIN, *SOMETHING BLUE*

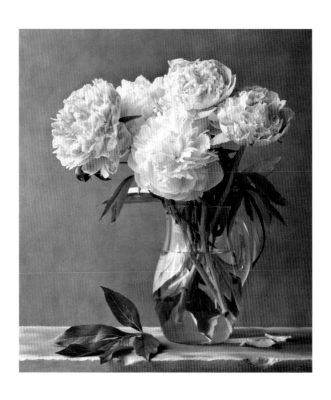

In the sweetness of friendship let there
be laughter, and sharing of pleasures.
For in the dew of little things the heart
finds its morning and is refreshed.

~ KAHLIL GIBRAN

AUGUST 23

Sometimes being a friend means mastering
the art of timing. There is a time for silence. A time
to let go and allow people to hurl themselves
into their own destiny. And a time to prepare
to pick up the pieces when it's all over.

~ GLORIA NAYLOR, *THE WOMEN OF BREWSTER PLACE*

AUGUST 22

There's all kinds
of love in the world,
and not all of it
looks like the stuff
in greeting cards.

~ JENNIFER WEINER,
BEST FRIENDS FOREVER

What is a friend? A single soul
dwelling in two bodies.

~ ARISTOTLE

As with all matters of the heart,
you'll know when you find it.

~ STEVE JOBS

AUGUST 19

If, instead of a gem, or even a flower,
we should cast the gift of a loving
thought into the heart of a friend,
that would be giving as the angels give.

~ GEORGE MACDONALD

A friend is a loved one who
awakens your life in order to free
the wild possibilities within you.

~ JOHN O'DONOHUE

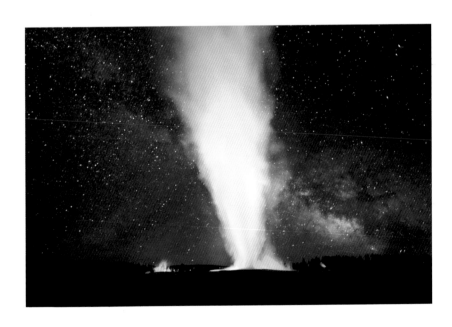

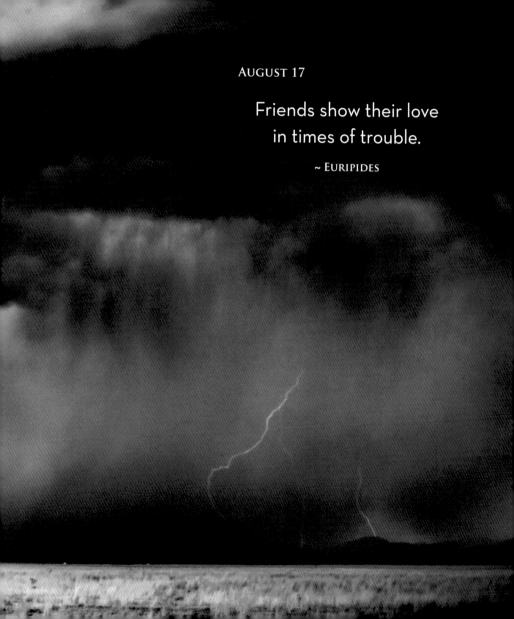

AUGUST 17

Friends show their love
in times of trouble.

~ EURIPIDES

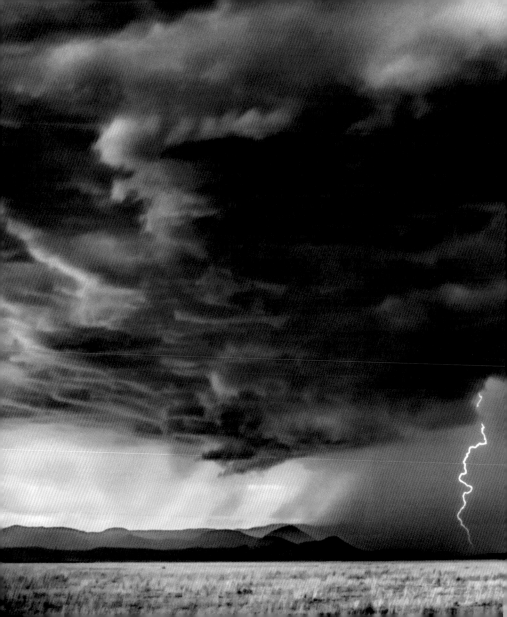

Be with those who help your being.

~ RUMI

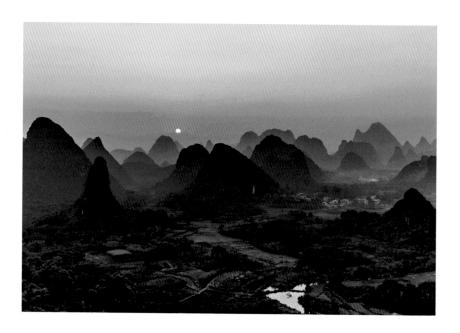

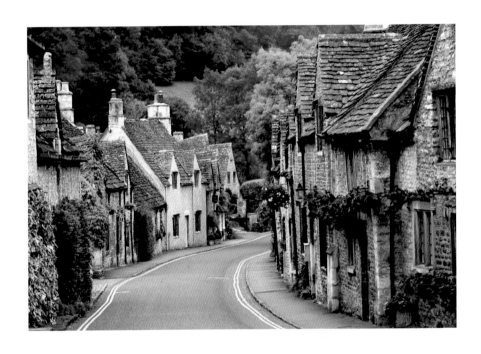

Stay is a charming word in a friend's vocabulary.

~ AMOS BRONSON ALCOTT

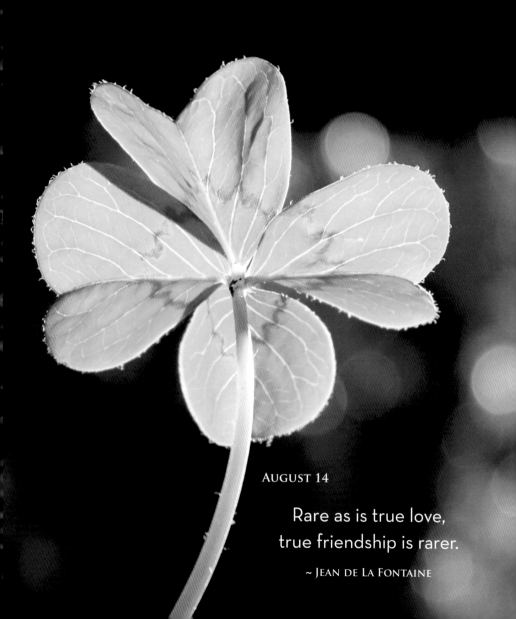

AUGUST 14

Rare as is true love,
true friendship is rarer.

~ JEAN DE LA FONTAINE

The arms of friendship are long
enough to reach from the one end
of the world to the other.

~ MICHEL DE MONTAIGNE

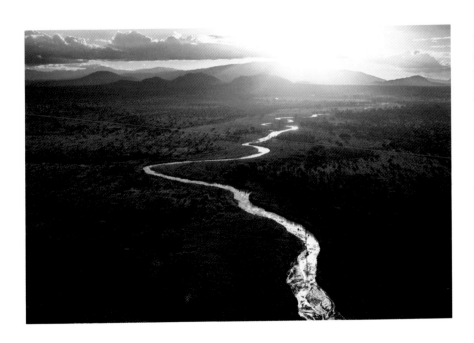

AUGUST 12

No friendship
is an accident.

~ O. HENRY

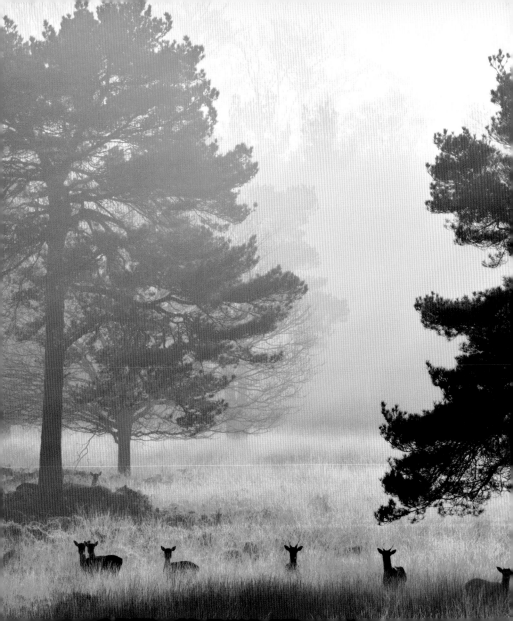

What draws people to be friends
is that they see the same truth.
They share it.

~ C. S. LEWIS

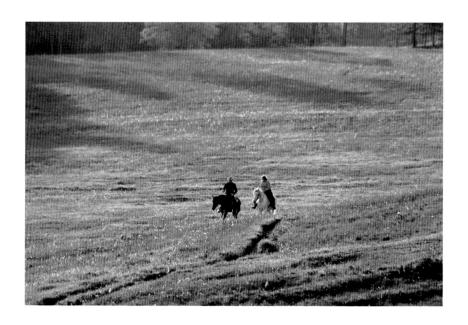

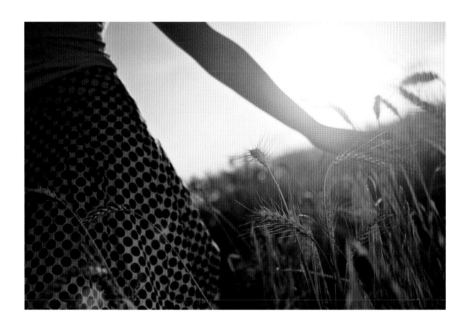

Love is the true means by which
the world is enjoyed: our love
to others, and others' love to us.

~ THOMAS TRAHERNE

August 9

'Tis the privilege of friendship to talk nonsense, and to have her nonsense respected.

~ Charles Lamb, *Essays of Elia*

Cherish your friends, stay true to your
principles, live passionately and fully and well.
Experience new things. Love and be loved,
if you ever get the chance.

~ DAVID NICHOLLS, *One Day*

AUGUST 7

The things that we love
tell us what we are.

~ St. Thomas Aquinas

You are never strong enough
that you don't need help.

~ CESAR CHAVEZ

If we would build on a sure foundation
in friendship, we must love friends
for their sake rather than for our own.

~ CHARLOTTE BRONTË

Friendship marks a life even more deeply
than love. Love risks degenerating
into obsession, friendship is
never anything but sharing.

~ ELIE WIESEL

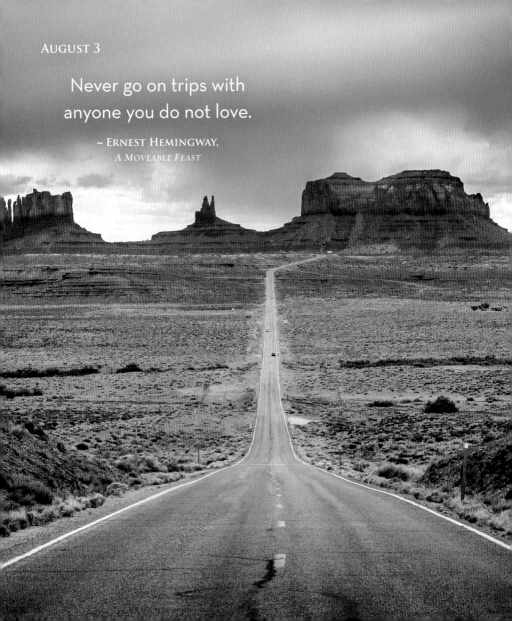

AUGUST 3

Never go on trips with
anyone you do not love.

~ ERNEST HEMINGWAY,
A MOVEABLE FEAST

Be silly. Be honest. Be kind.

~ RALPH WALDO EMERSON

AUGUST 1

To love is to recognize yourself in another.

~ ECKHART TOLLE

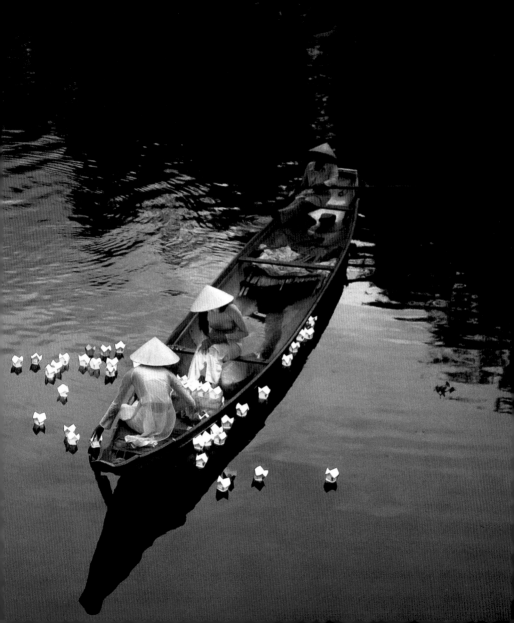

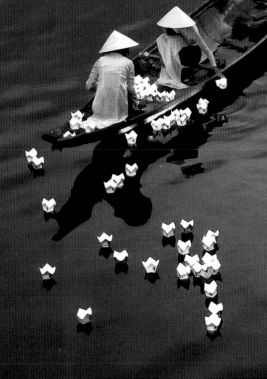

AUGUST

FRIENDSHIP

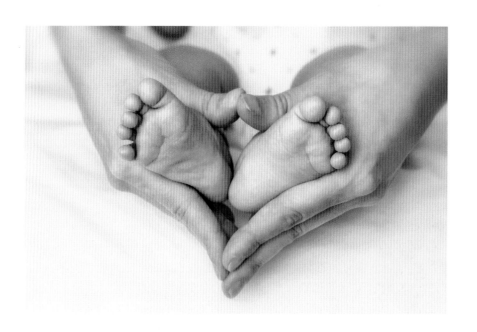

JULY 31

The more love you give away,
the more love you will have.

~ JOHN O'DONOHUE

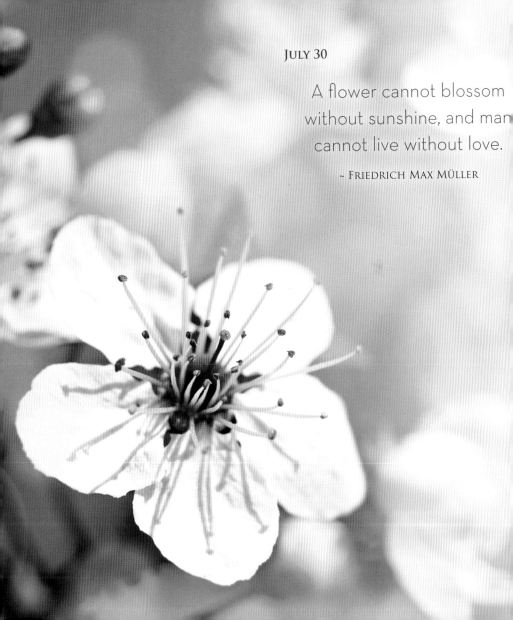

JULY 30

A flower cannot blossom
without sunshine, and man
cannot live without love.

~ FRIEDRICH MAX MÜLLER

Love breeds love.

~ YOKO ONO

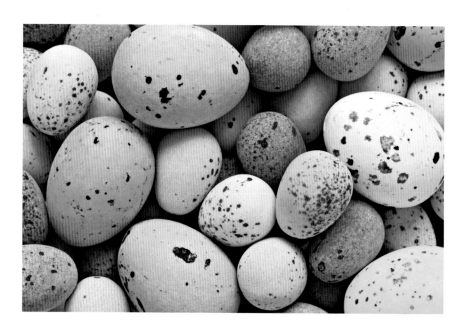

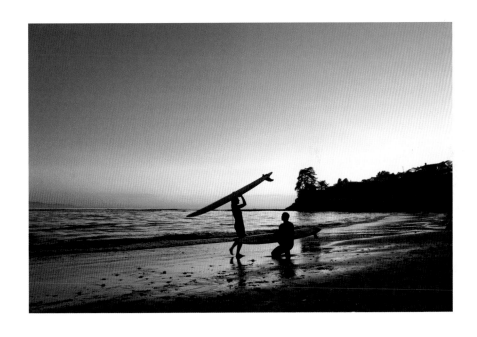

Stay close to any sound that
makes you glad you are alive.

~ HAFEZ

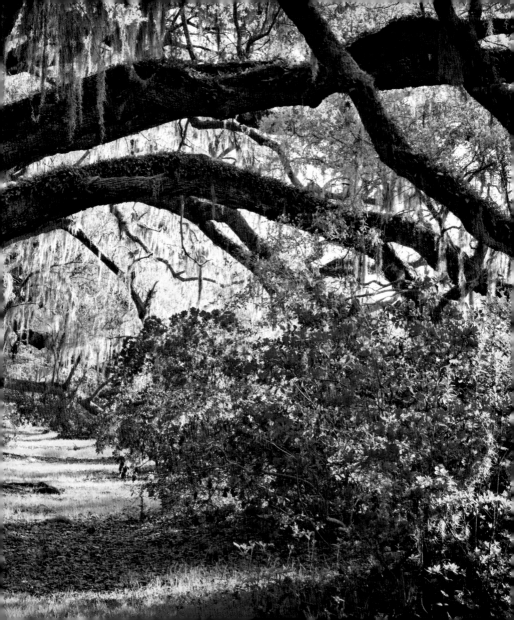

JULY 27

We can only learn
to love by loving.

~ IRIS MURDOCH, *THE BELL*

When we hug, our hearts
connect and we know that we
are not separate beings.

~ THICH NHAT HANH

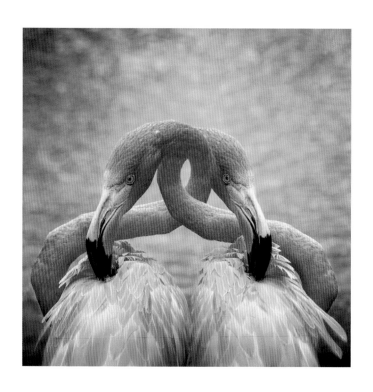

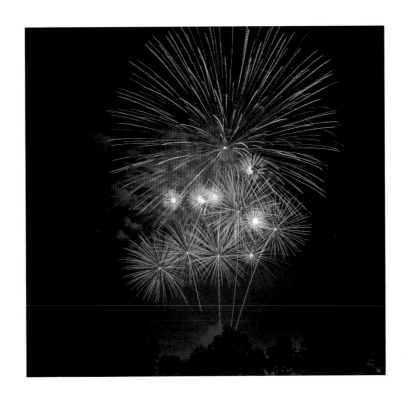

JULY 25

To have joy, one must share it.

~ GEORGE GORDON LORD BYRON

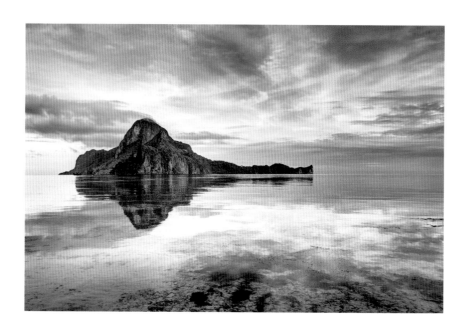

JULY 24

The object of love is the best and
most beautiful. Try to live up to it.

~ JOHN STEINBECK

They who give have all things;
they who withhold have nothing

~ HINDU PROVERB

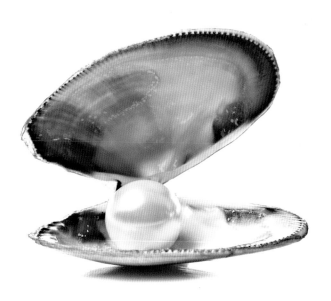

JULY 22

Blessed is the
influence of one true,
loving human soul
on another.

~ GEORGE ELIOT

When someone loves you it's like having
a blanket all round your heart.

~ HELEN FIELDING, *BRIDGET JONES'S DIARY*

Affection is responsible for nine-tenths
of whatever solid and durable happiness
there is in our natural lives.

~ C. S. LEWIS

JULY 19

There are very few of us who
have heart enough to be really
in love without encouragement.

~ JANE AUSTEN, *PRIDE AND PREJUDICE*

Accustom yourself continually
to make many acts of love, for they
enkindle and melt the soul.

~ TERESA OF ÁVILA

JULY 17

The pleasure of love is in loving.
We are happier in the passion
we feel than in that we inspire.

~ FRANÇOIS DE LA ROCHEFOUCAULD

JULY 16

Love is a power which produces love.

~ ERICH FROMM

We live in the world when we love it.

~ RABINDRANATH TAGORE

We are biologically, cognitively,
physically, and spiritually wired to love,
be loved, and to belong.

~ BRENÉ BROWN

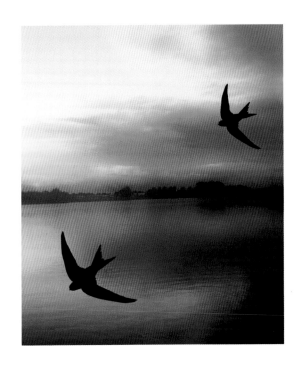

JULY 13

Life must be rich and full
of loving—it's no good otherwise,
no good at all, for anyone.

~ JACK KEROUAC

JULY 12

Who would live
and not love?

~ RACHEL RUSSELL

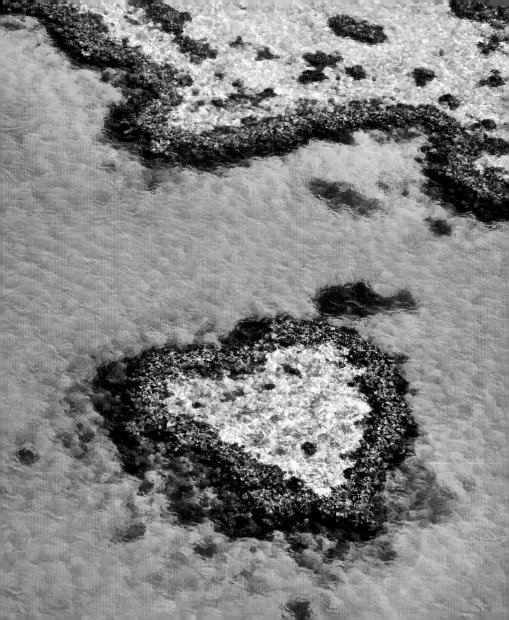

Love is all we have, the only way
that each can help the other.

~ EURIPIDES

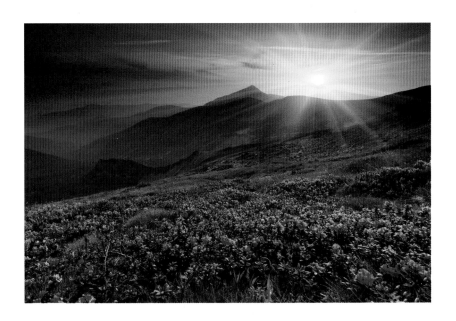

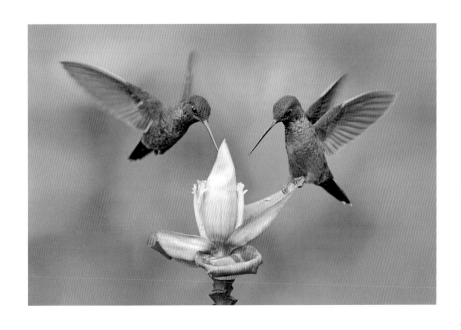

JULY 10

There is only one happiness in life,
to love and be loved.

~ GEORGE SAND

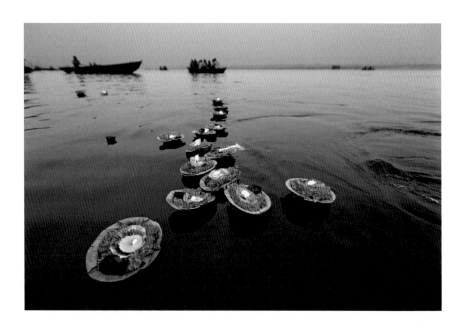

JULY 9

Love grows by giving. The love we
give away is the only love we keep.
The only way to retain love
is to give it away.

~ ELBERT HUBBARD

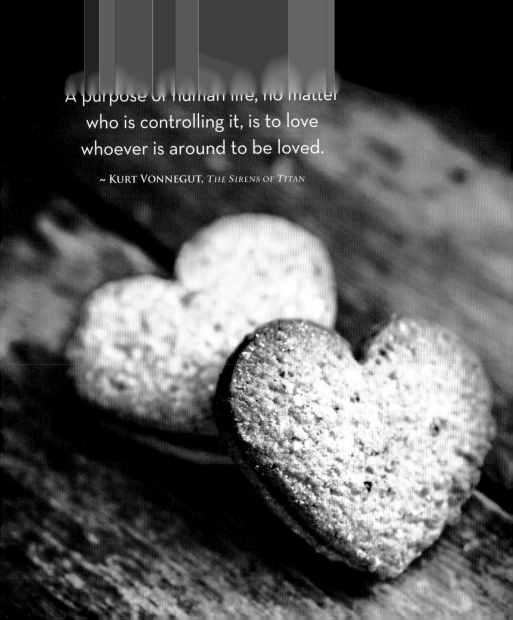

A purpose of human life, no matter who is controlling it, is to love whoever is around to be loved.

~ KURT VONNEGUT, *The Sirens of Titan*

JULY 7

If it is true that there
are as many minds
as there are heads,
then there are
as many kinds of love
as there are hearts.

~ LEO TOLSTOY, *ANNA KARENINA*

Everyone longs to be loved.
And the greatest thing we can do
is to let people know that they
are loved and capable of loving.

~ FRED ROGERS

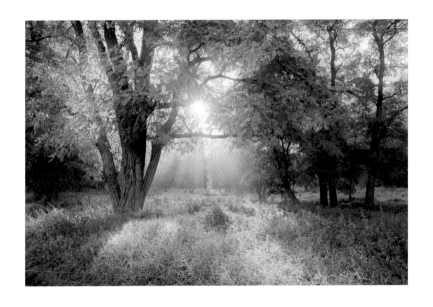

We need love in order to live happily,
as much as we need oxygen
in order to live at all.

~ MARIANNE WILLIAMSON

JULY 4

We must find time to stop
and thank the people who make
a difference in our lives.

~ JOHN F. KENNEDY

You yourself, as much as anybody
in the entire universe, deserve
your love and affection.

~ BUDDHA

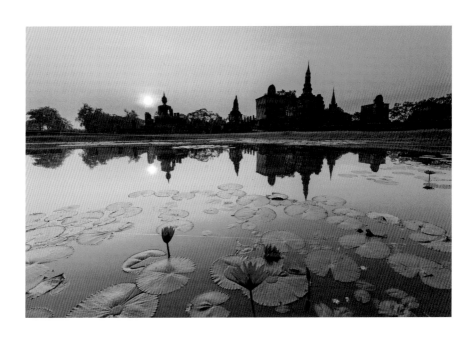

What is done in love is well done.

~ VINCENT VAN GOGH

JULY 1

Spread love everywhere you go.
Let no one ever come to you
without leaving better and happier.

~ MOTHER TERESA

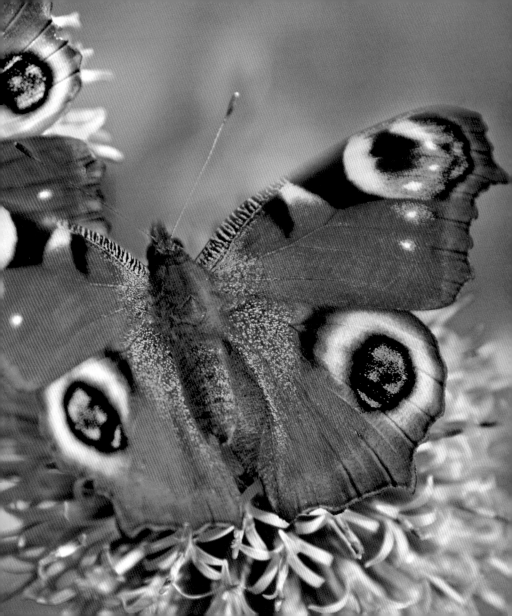

JULY

AFFECTION

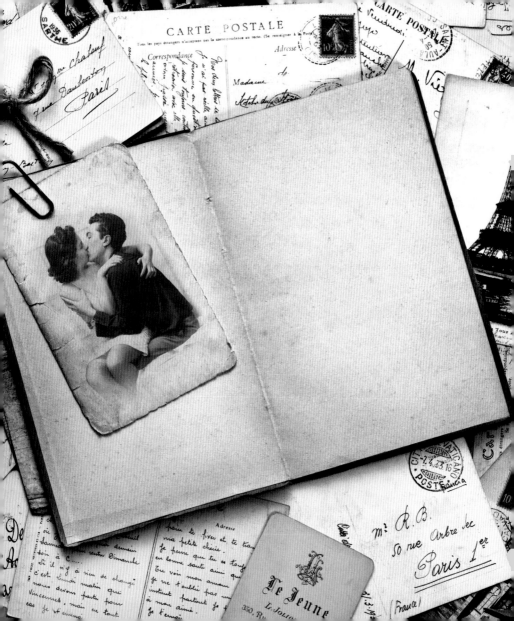

JUNE 30

Communication is
truth; communication
is happiness . . .
to conceal nothing;
to pretend nothing;
if we are ignorant
to say so; if we love
our friends to
let them know it.

~ VIRGINIA WOOLF

JUNE 29

You must love in such a way
that the person you love
feels free.

~ THICH NHAT HANH

There are times to stay put, and what you want
will come to you, and there are times to go out
into the world and find such a thing for yourself.

~ LEMONY SNICKET

It is essential that we be convinced of the
goodness of human nature, and we must
act as though people are good.

~ JOHN CAGE

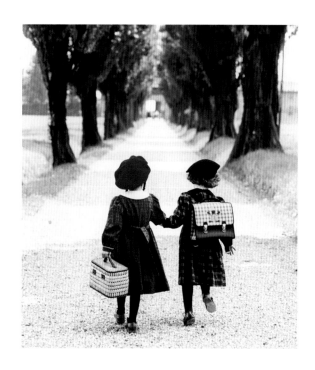

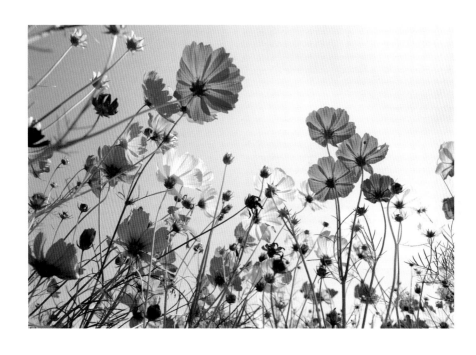

June 26

Above all, be the heroine
of your life, not the victim.

~ Nora Ephron

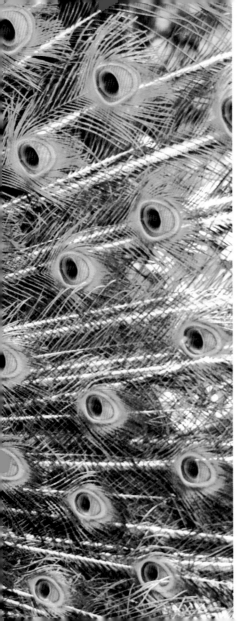

JUNE 25

Better by far to be
good and courageous
and bold and to make
a difference.

~ DAVID NICHOLLS, *ONE DAY*

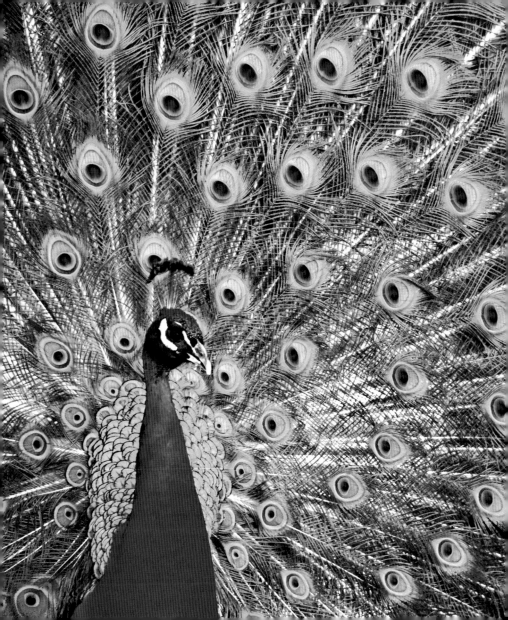

Trust is the fruit of a relationship in
which you know you are loved.

~ WILLIAM PAUL YOUNG

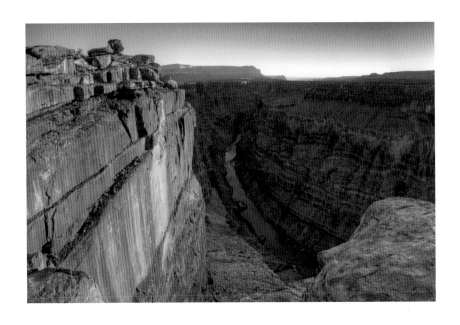

June 23

Being deeply loved by someone
gives you strength, while loving
someone deeply gives you courage.

~ Lao-tzu

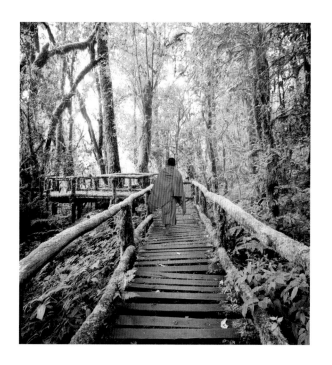

JUNE 22

The place to improve the world
is first in one's own heart and hands,
and then work outward from there.

~ ROBERT M. PIRSIG

I have learned not to worry
about love, but to honor
its coming with all my heart.

~ ALICE WALKER

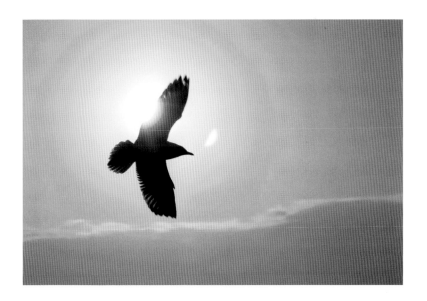

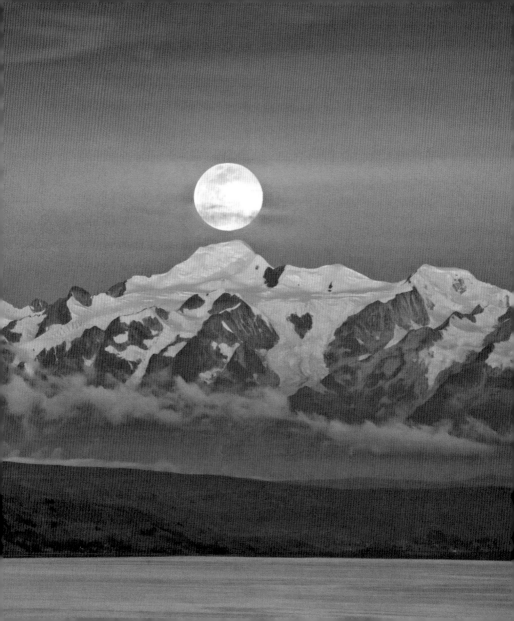

JUNE 20

Have enough courage
to trust love one
more time and always
one more time.

~ MAYA ANGELOU

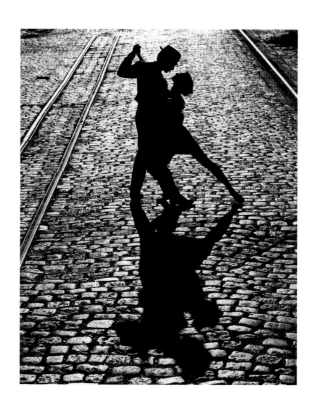

JUNE 19

It's the heart afraid of breaking
that never learns to dance.

~ XIAOLU GUO

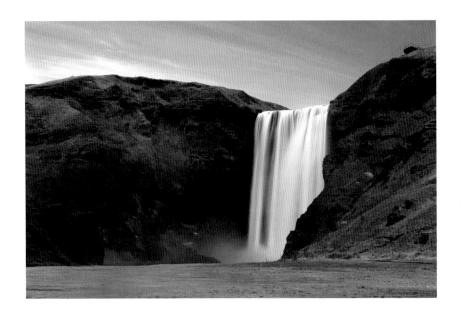

JUNE 18

Love meant jumping off a cliff and
trusting that a certain person would
be there to catch you at the bottom.

~ JODI PICOULT, *Second Glance*

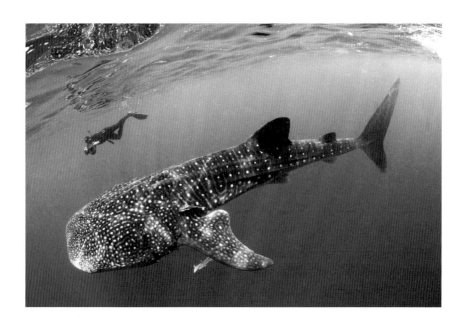

JUNE 17

What wonderful thing
didn't start out scary?

~ ISAAC MARION

We need, in love, to practice only this:
letting each other go. For holding on
comes easily; we do not need to learn it.

—RAINER MARIA RILKE

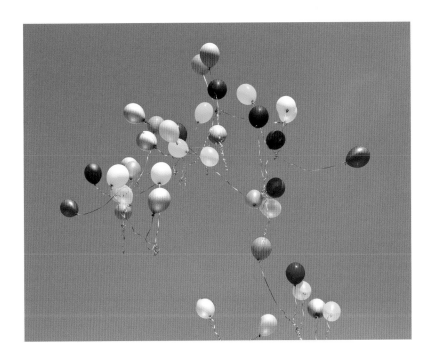

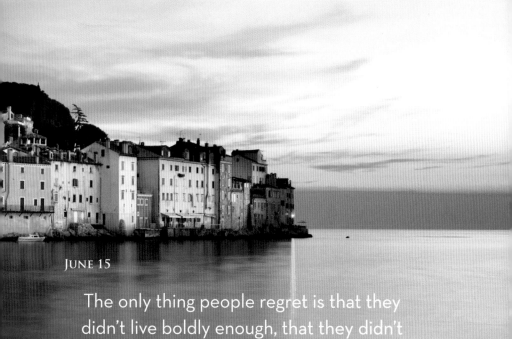

JUNE 15

The only thing people regret is that they
didn't live boldly enough, that they didn't
invest enough heart, didn't love enough.
Nothing else really counts at all.

~ TED HUGHES

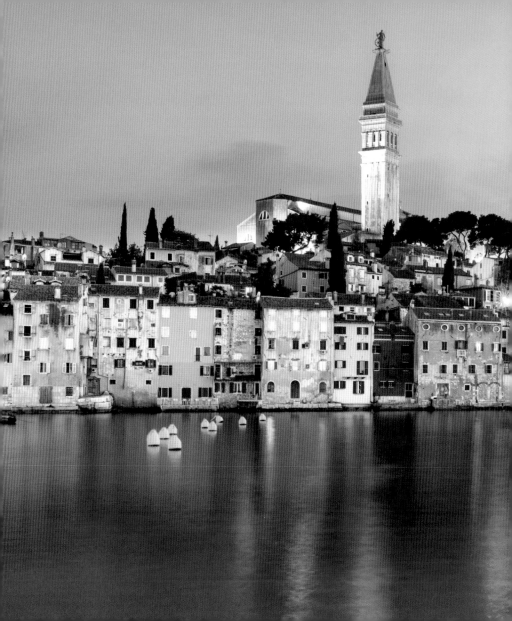

JUNE 14

Have you ever been in love? Horrible isn't it?
It makes you so vulnerable. It opens
your chest and it opens up your heart
and it means that someone can get
inside you and mess you up.

~ NEIL GAIMAN

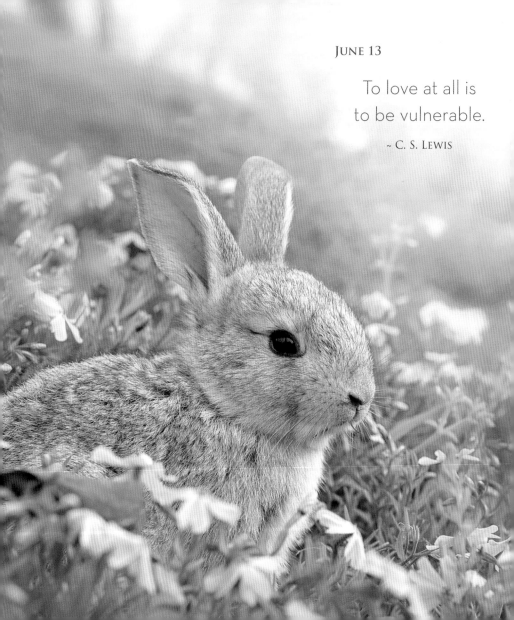

JUNE 13

To love at all is
to be vulnerable.

~ C. S. LEWIS

The supreme happiness of life is the conviction
that we are loved; loved for ourselves—
say rather, loved in spite of ourselves.

~ VICTOR HUGO, *LES MISÉRABLES*

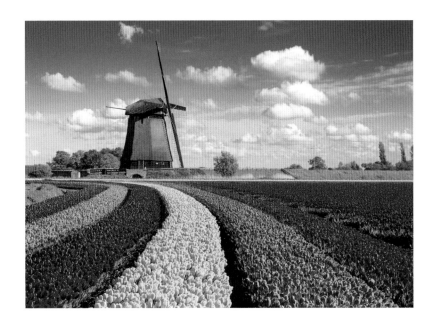

JUNE 11

Happiness comes more from loving
than being loved. To love, and to be
hurt often, and to love again—this is
the brave and happy life.

~ J. E. BUCKROSE

JUNE 10

If we are brave enough
often enough,
we will fall;
this is the physics
of vulnerability.

~ Brené Brown

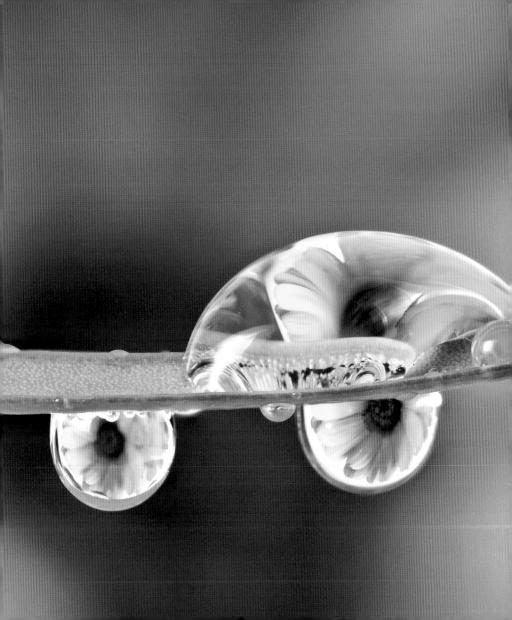

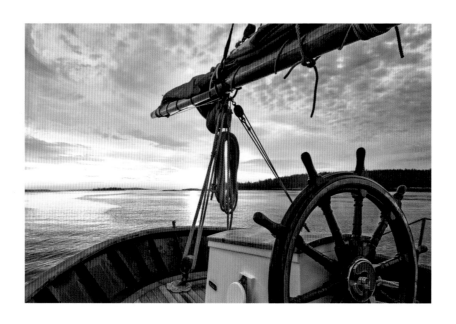

JUNE 9

When you love someone, you have
to have trust and confidence.
Love without trust is not yet love.

~ THICH NHAT HANH

You will never truly know yourself,
or the strength of your relationships,
until both have been tested by adversity.

~ J. K. ROWLING

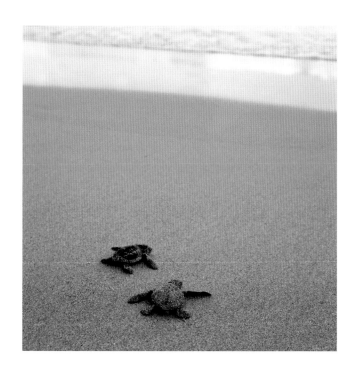

The purpose of an intimate relationship
is not that it be a place where we can hide
from our weaknesses, but rather where
we can safely let them go.

~ MARIANNE WILLIAMSON

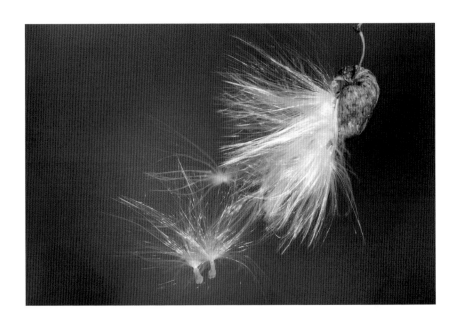

JUNE 6

If you love somebody, let them go,
for if they return, they were always yours.
If they don't, they never were.

~ KAHLIL GIBRAN

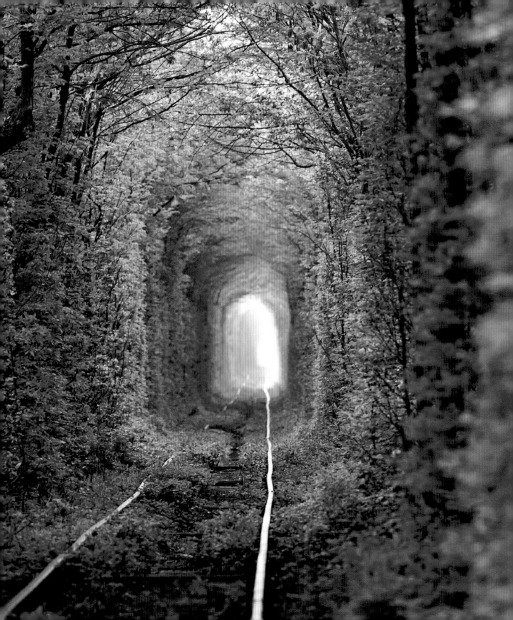

JUNE 5

Every single event
in life happens
in an opportunity
to choose love
over fear.

~ OPRAH WINFREY

The ultimate act of bravery does not
take place on a battlefield. It takes place
in your heart, when you have the courage
to honor your character, your intellect,
your inclinations and yes, your soul.

~ ANNA QUINDLEN

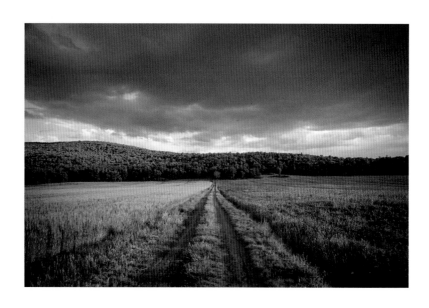

JUNE 3

I've been absolutely terrified every moment
of my life—and I've never let it keep me
from doing a single thing I wanted to do.

~ GEORGIA O'KEEFFE

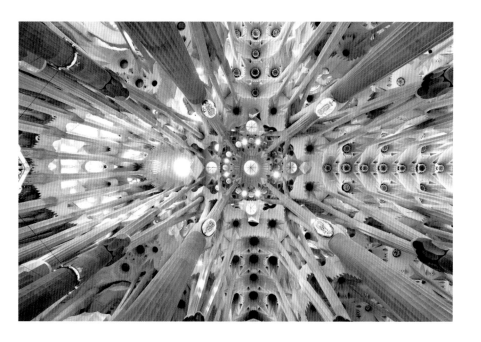

JUNE 2

The heart has its reasons, which reason
does not know . . . We know truth, not only
by the reason, but also by the heart.

~ BLAISE PASCAL

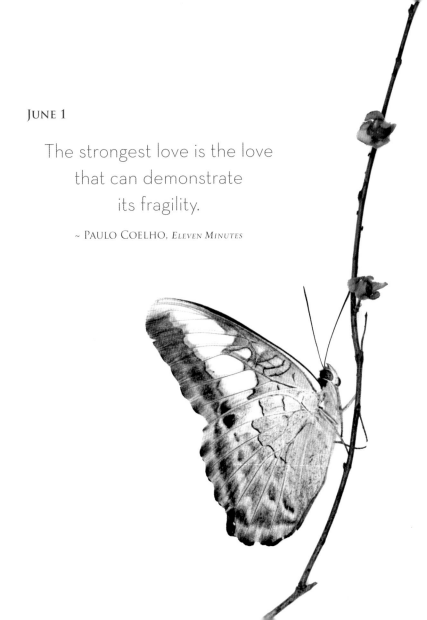

JUNE 1

The strongest love is the love
that can demonstrate
its fragility.

~ PAULO COELHO, *Eleven Minutes*

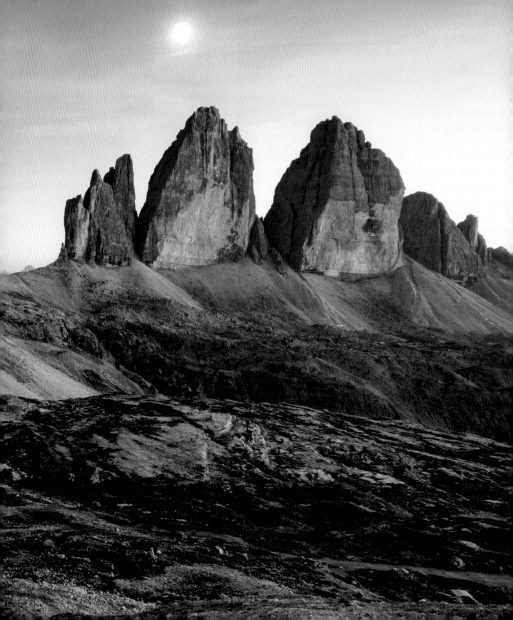

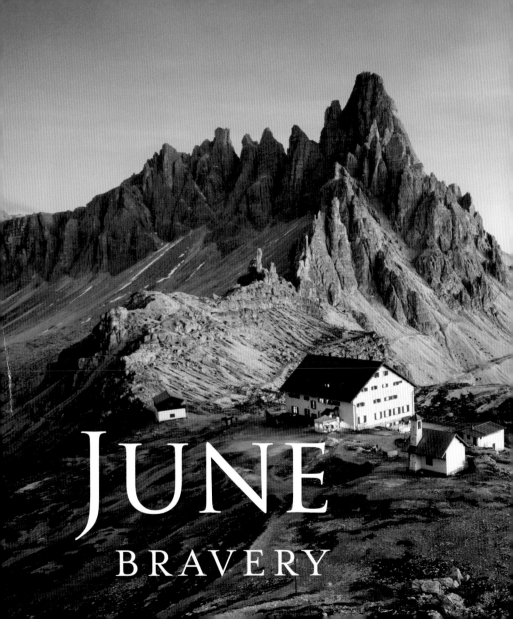

JUNE

BRAVERY

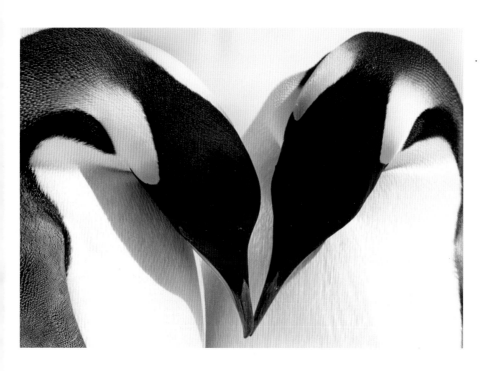

MAY 31

Be a little kinder than you have to.

~ E. LOCKHART, *We Were Liars*

Of all things we mortals are called upon to do, the most difficult is forgiveness; in order to truly do it, you will probably have to behave as if you already have forgiven for quite a while before you have actually done so.

~ MARION ZIMMER BRADLEY, *ANCESTORS OF AVALON*

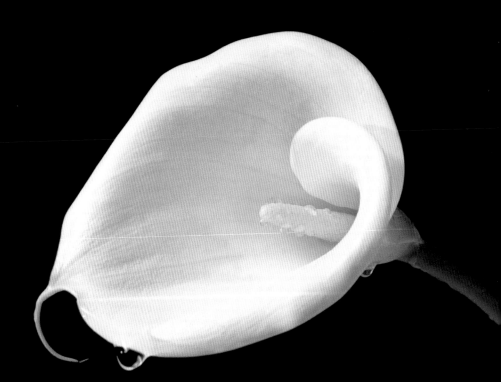

Remember, no matter how foolish your deeds,
those who love you will love you still.

~ SOPHOCLES, *Antigone*

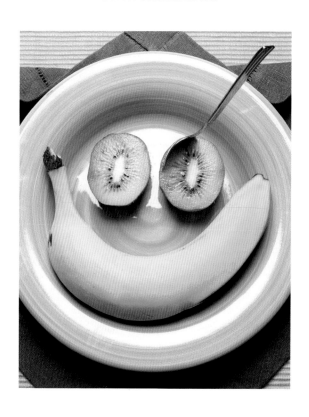

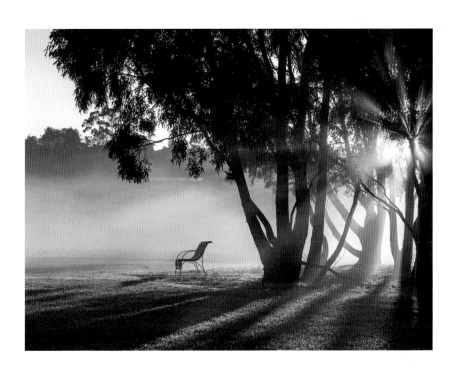

MAY 28

Love is so short, forgetting is so long.

~ PABLO NERUDA

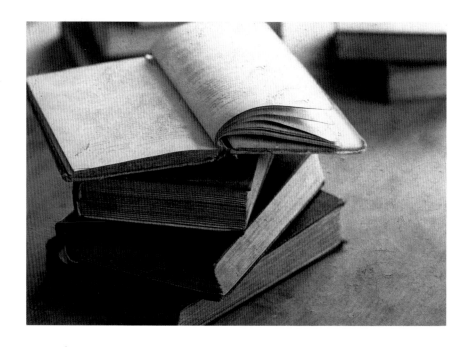

MAY 27

You don't love because: you love despite;
not for the virtues, but despite the faults.

~ WILLIAM FAULKNER

Remember that forgiveness too is a power.

~ MARGARET ATWOOD, THE HANDMAID'S TALE

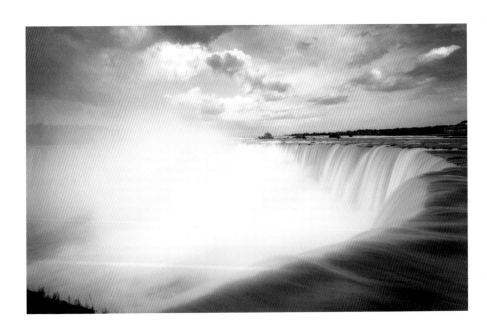

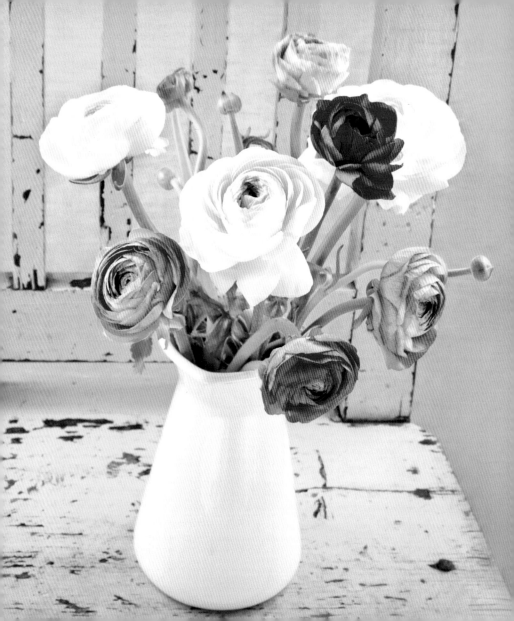

Love is by definition
an unmerited gift;
being loved
without meriting
it is the very proof
of real love.

~ MILAN KUNDERA, *SLOWNESS*

MAY 24

Love and compassion are necessities,
not luxuries. Without them,
humanity cannot survive.

~ DALAI LAMA XIV

Slide the weight from your shoulders
and move forward. You are afraid
you might forget, but you never will.
You will forgive and remember.

~ BARBARA KINGSOLVER, *THE POISONWOOD BIBLE*

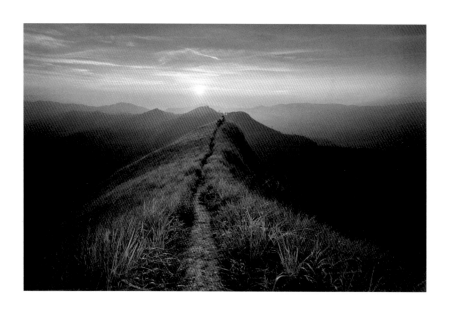

Perhaps it is our imperfections that
make us so perfect for one another!

~ *EMMA*, 1996 SCREENPLAY

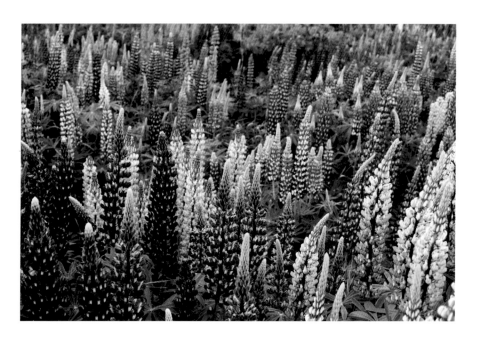

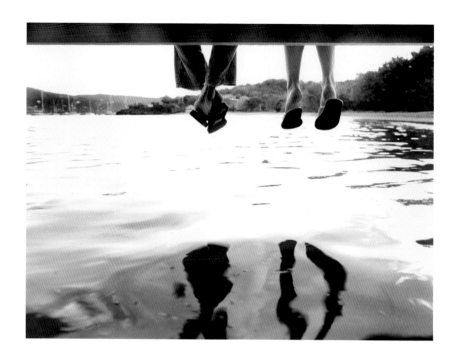

Where the myth fails, human love begins.
Then we love a human being, not our dream,
but a human being with flaws.

~ ANAÏS NIN

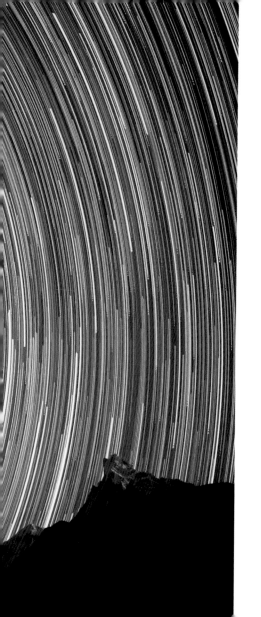

May 20

To err is human;
to forgive, divine.

~ ALEXANDER POPE

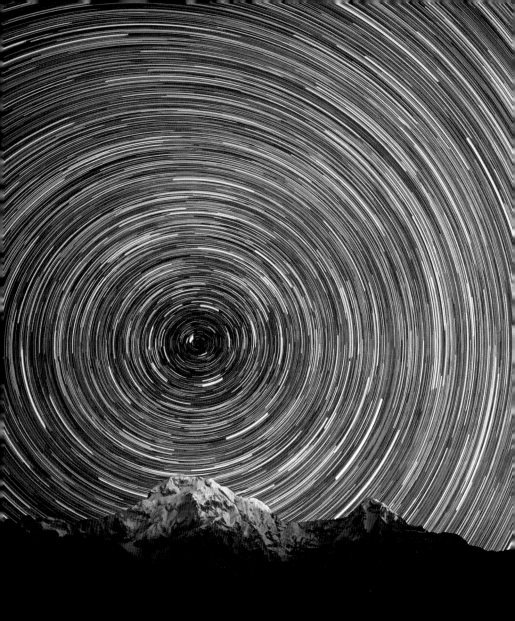

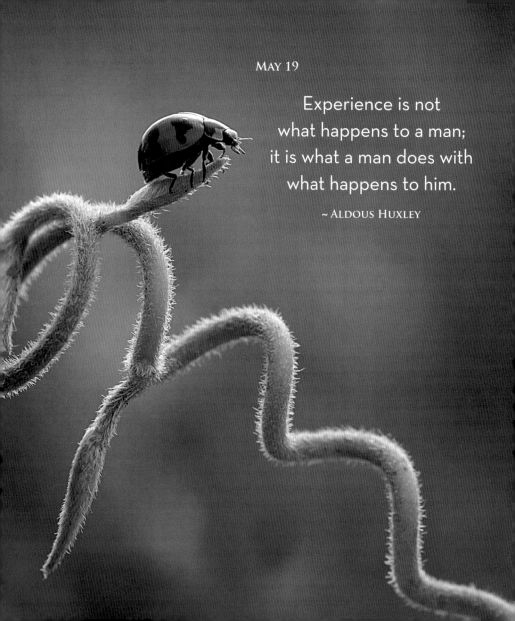

MAY 19

Experience is not
what happens to a man;
it is what a man does with
what happens to him.

~ Aldous Huxley

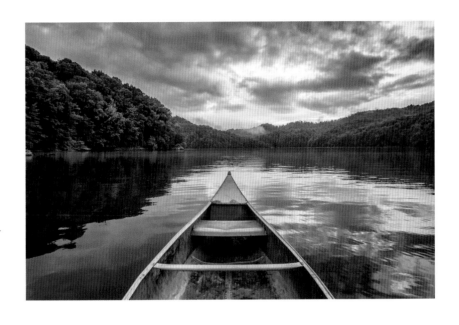

Don't ruin the present
with the ruined past.

~ ELLEN GILCHRIST

MAY 17

Sometimes letting things go is an act of far
greater power than defending or hanging on.

~ ECKHART TOLLE

True forgiveness is when you can say,
"Thank you for that experience."

~ OPRAH WINFREY

MAY 15

Mistakes are a fact of life:
It is the response to
the error that counts.

~ NIKKI GIOVANNI

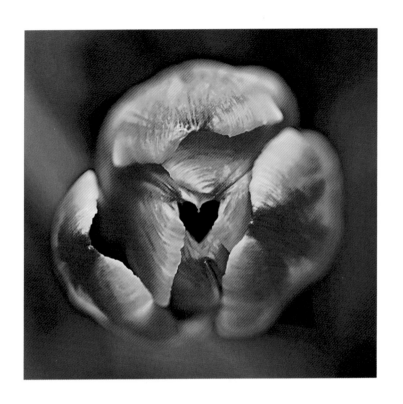

MAY 14

People are very bad and very good.
A little love goes a long way.

~ AMY POEHLER

We are told that people stay in love because of chemistry, or because they remain intrigued with each other, because of many kindnesses, because of luck. But part of it has got to be forgiveness and gratefulness.

~ ELLEN GOODMAN

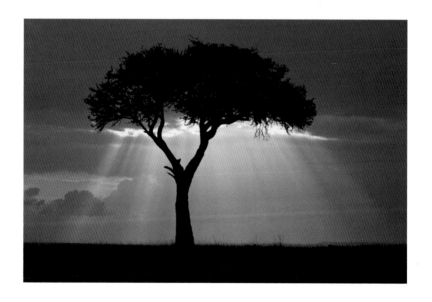

Moments of kindness and reconciliation
are worth having, even if the parting
has to come sooner or later.

~ ALICE MUNRO, *THE PROGRESS OF LOVE*

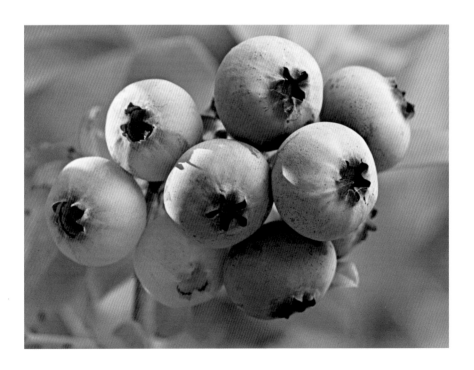

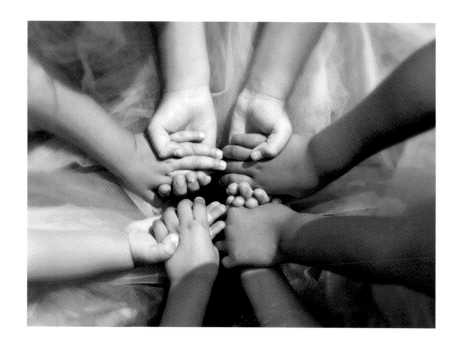

MAY 11

Compassion is an unstable emotion.
It needs to be translated into action,
or it withers.

~ SUSAN SONTAG

Perfection is inhuman.
Human beings are
not perfect. What
evokes our love . . .
is the imperfection
of the human being.

~ JOSEPH CAMPBELL

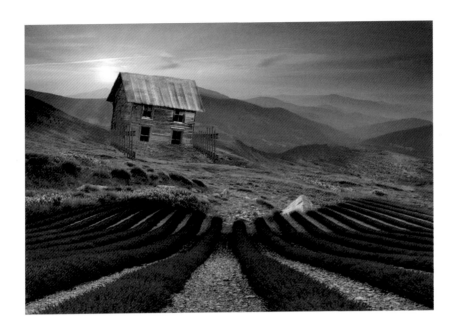

MAY 9

Let us forget with generosity
those who cannot love us.

~ PABLO NERUDA

What cannot be said will be wept.

~ SAPPHO

Blessed are the hearts that can bend;
they shall never be broken.

~ ALBERT CAMUS

MAY 6

Until we have seen someone's darkness,
we don't really know who they are.
Until we have forgiven someone's darkness,
we don't really know what love is.

~ MARIANNE WILLIAMSON

MAY 5

There is always
something left to love.
And if you ain't
learned that, you ain't
learned nothing.

~ LORRAINE HANSBERRY,
A RAISIN IN THE SUN

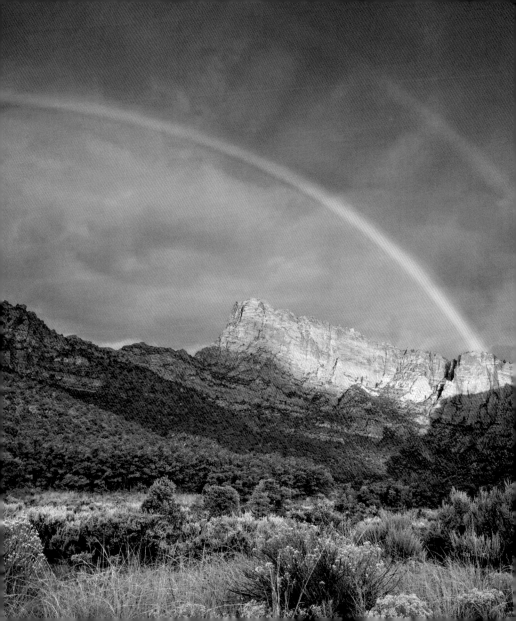

Forgiveness is not a single act,
but a matter of constant practice.

~ DIANA GABALDON, *DRUMS OF AUTUMN*

Regrets are as personal
as fingerprints.

~ MARGARET CULKIN BANNING

You have to say I am forgiven again
and again until it becomes the story
you believe about yourself.

~ CHERYL STRAYED

MAY 1

When you forgive, you love.

~ JON KRAKAUER

MAY

FORGIVENESS

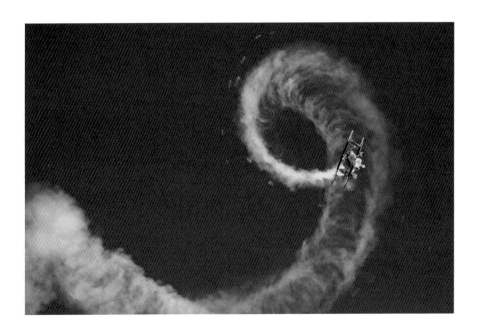

APRIL 30

If you are interested in something,
no matter what it is, go at it full speed.
Embrace it with both arms, hug it, love it
and above all become passionate
about it. Lukewarm is no good.

~ ROALD DAHL, *MY UNCLE OSWALD*

You should be kissed and often,
by someone who knows how.

~ MARGARET MITCHELL, *GONE WITH THE WIND*

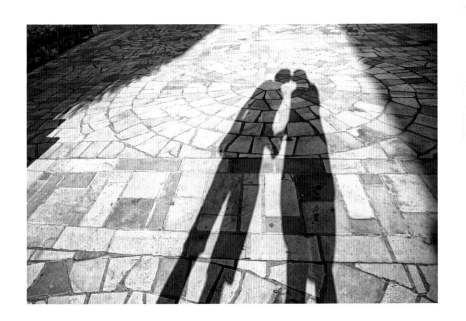

What she had realized was that love
was that moment when your heart
was about to burst.

~ STIEG LARSSON, *THE GIRL WITH THE DRAGON TATTOO*

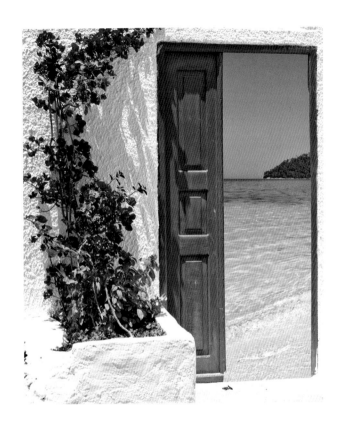

APRIL 27

Love is a striking example of how
little reality means to us.

~ MARCEL PROUST

APRIL 26

Of all forms of caution,
caution in love is
perhaps the most fatal
to true happiness.

~ BERTRAND RUSSELL

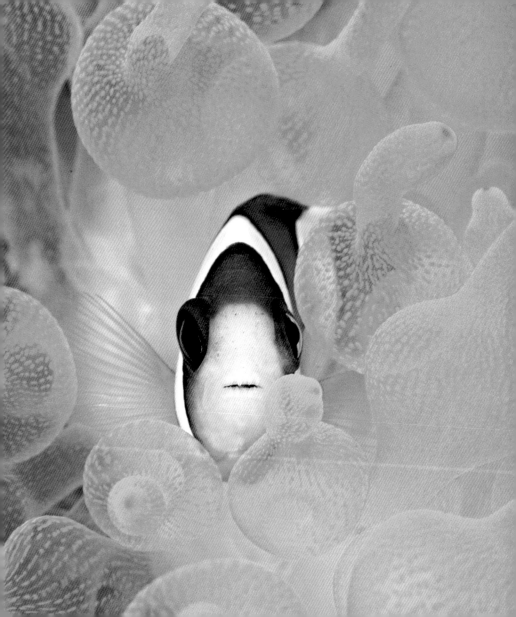

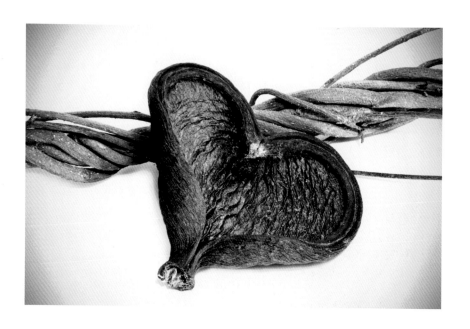

APRIL 25

The madness of love is the greatest
of heaven's blessings.

~ PLATO

Whatever you're meant to do,
do it now. The conditions
are always impossible.

~ DORIS LESSING

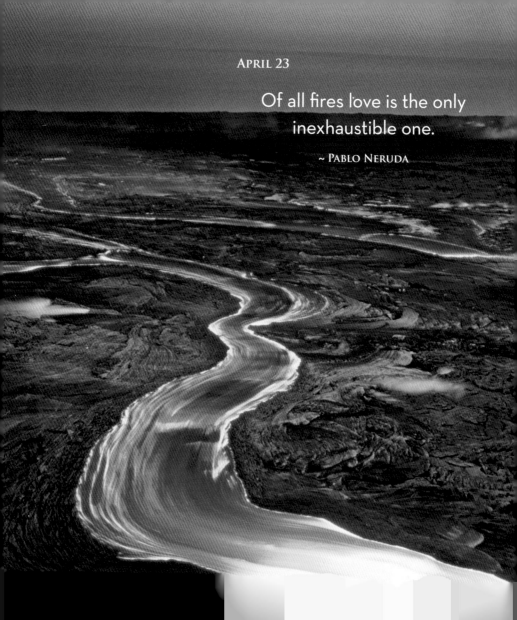

APRIL 23

Of all fires love is the only
inexhaustible one.

~ PABLO NERUDA

APRIL 22

You have to love. You have to feel.
It is the reason you are here on earth.
You are here to risk your heart.
You are here to be swallowed up.

~ LOUISE ERDRICH, *THE PAINTED DRUM*

APRIL 21

If I create from the heart, nearly
everything works; if from the head,
almost nothing.

~ MARC CHAGALL

There is scarcely any passion
without struggle.

~ Albert Camus

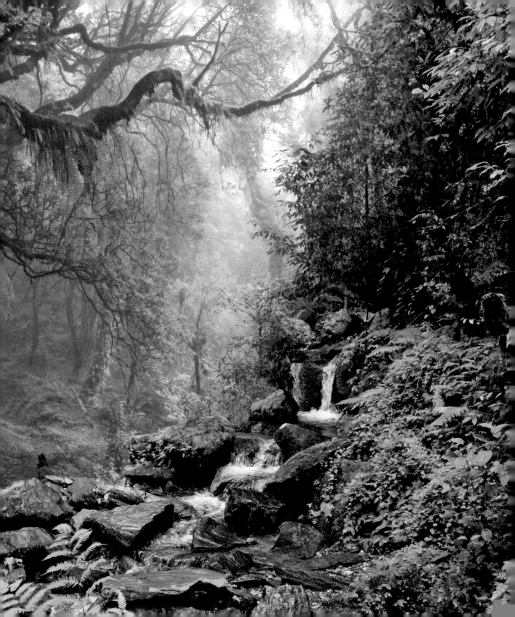

Be in love
with your life.
Every detail
of it.

~ JACK KEROUAC

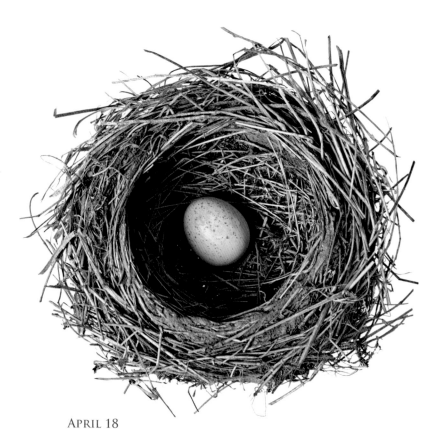

APRIL 18

All serious daring starts from within.

~ EUDORA WELTY

If you have a body, you are
entitled to the full range of feelings.
It comes with the package.

~ ANNE LAMOTT

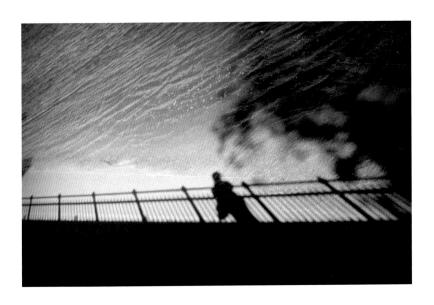

The aim of life is to live, and
to live means to be aware, joyously,
drunkenly, serenely, divinely aware.

~ HENRY MILLER

You well know that the hours in which
I hate you are those when my love for you
has become a passion outrunning all reason.

~ JULIE-JEANNE-ÉLÉONORE DE LESPINASSE

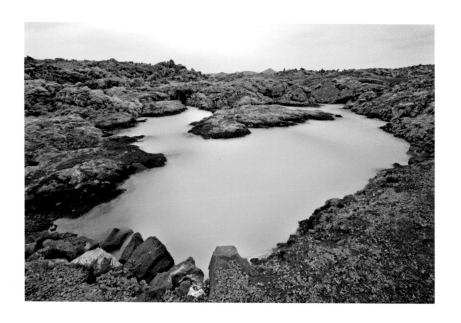

APRIL 14

One can be the master of what one does,
but never of what one feels.

~ GUSTAVE FLAUBERT

When the heart speaks, the mind
finds it indecent to object.

~ MILAN KUNDERA, *THE UNBEARABLE LIGHTNESS OF BEING*

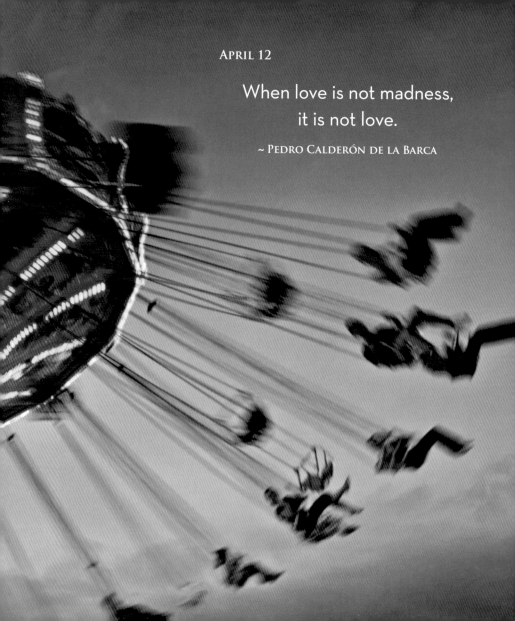

APRIL 12

When love is not madness,
it is not love.

~ PEDRO CALDERÓN DE LA BARCA

APRIL 11

What is passion? It is surely
the becoming of a person.

~ JOHN BOORMAN

Live the full life of the mind,
exhilarated by new ideas,
intoxicated by the romance
of the unusual.

~ ERNEST HEMINGWAY

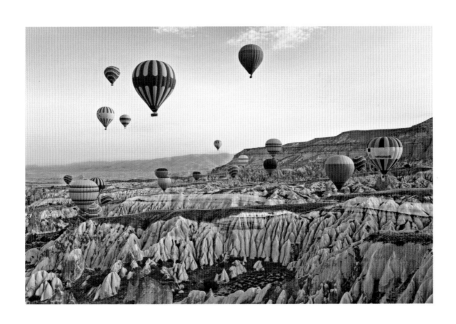

An awake heart is like a sky
that pours light.

~ HAFEZ

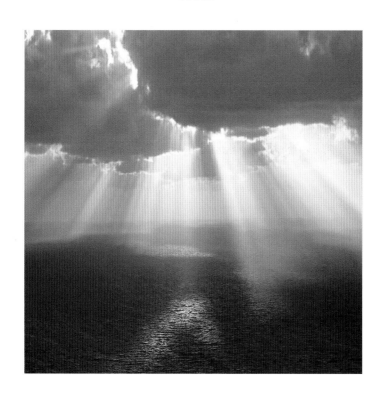

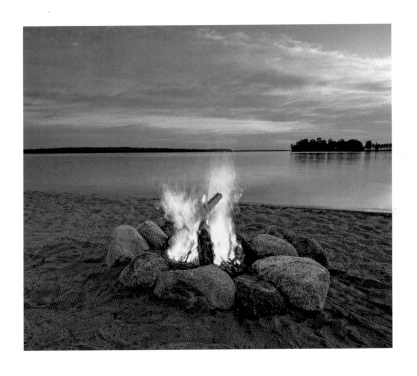

APRIL 8

To love is to burn, to be on fire.

~ *SENSE AND SENSIBILITY*, 1995 SCREENPLAY

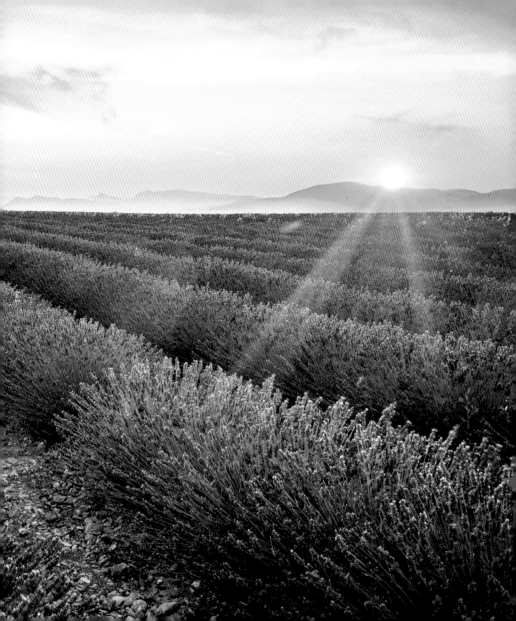

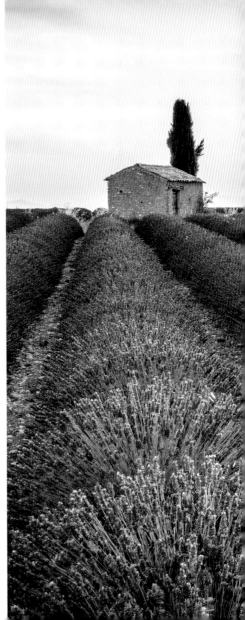

APRIL 7

I am seeking,
I am striving,
I am in it with
all my heart.

~ Vincent van Gogh

There is no instinct like
that of the heart.

~ GEORGE GORDON LORD BYRON

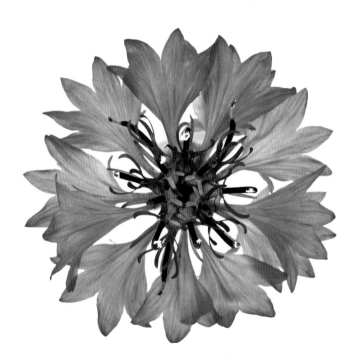

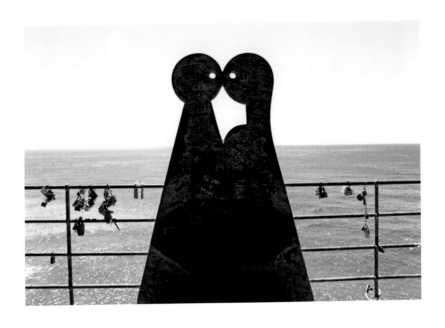

Because love is the meeting
point of truth and magic.

~ JULIAN BARNES, *LEVELS OF LIFE*

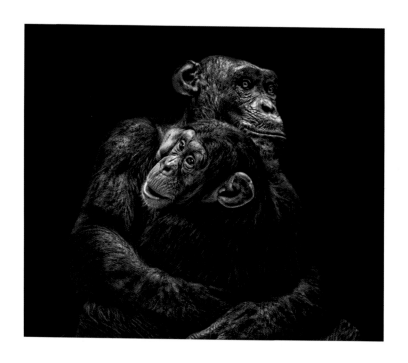

APRIL 4

To love and be loved is the most
empowering and exhilarating
of all human emotions.

~ JANE GOODALL

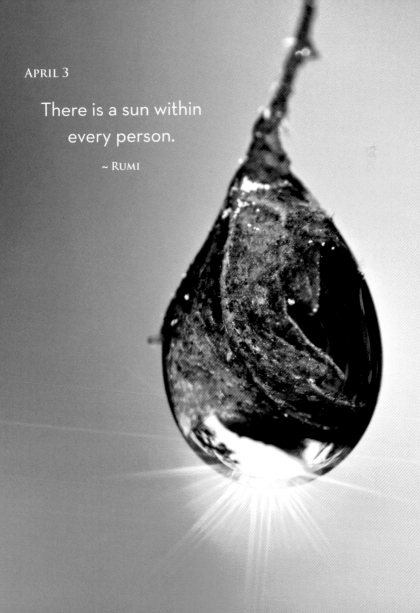

APRIL 3

There is a sun within
every person.

~ RUMI

It is the soul's duty to be loyal
to its own desires. It must abandon
itself to its master passion.

~ REBECCA WEST

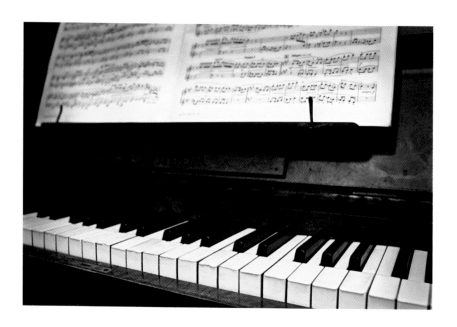

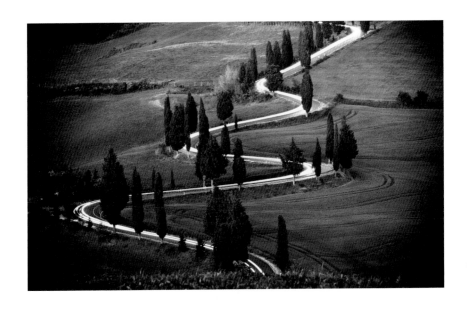

APRIL 1

Love is many things,
none of them logical.

~ WILLIAM GOLDMAN,
THE PRINCESS BRIDE

APRIL

PASSION

Certain things in life simply have to be
experienced—and never explained.
Love is such a thing.

~ PAULO COELHO, *MAKTUB*

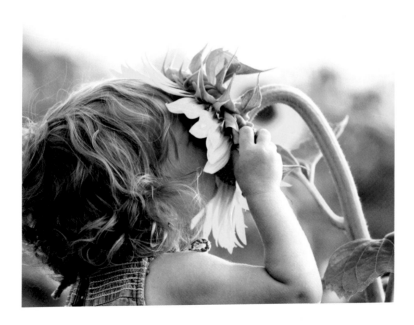

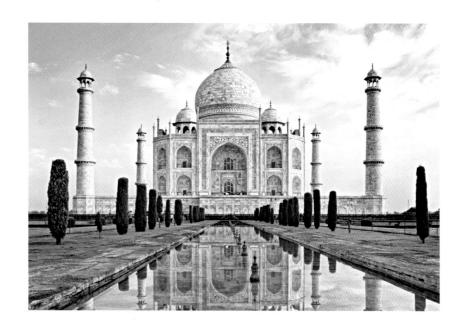

MARCH 30

In matters of the heart, nothing is true
except the improbable.

~ GERMAINE DE STAËL

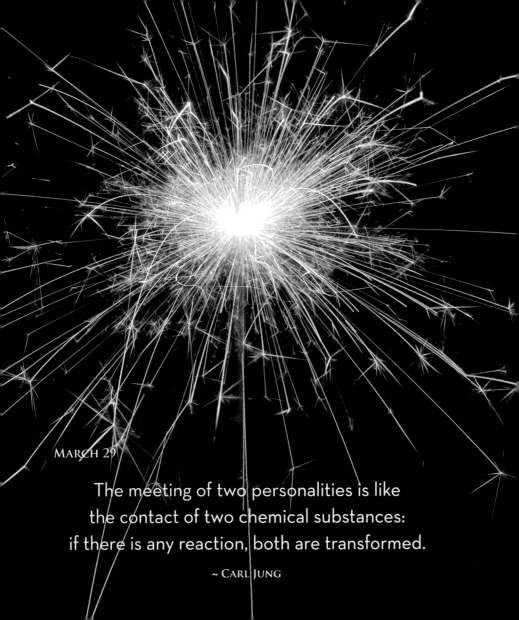

MARCH 29

The meeting of two personalities is like
the contact of two chemical substances:
if there is any reaction, both are transformed.

~ CARL JUNG

There were thousands and thousands
of forms of joy in the world, but . . .
all were essentially one and the same,
namely, the joy of being able to love.

~ MICHAEL ENDE, *THE NEVERENDING STORY*

March 27

Love is space and time
measured by the heart.

~ Marcel Proust

It is with the soul that we grasp the essence
of another human being, not with the mind,
nor even with the heart.

~ HENRY MILLER

March 25

The more I wonder . . . the more I love.

~ Alice Walker

MARCH 24

All the world is made of faith,
and trust, and pixie dust.

~ *PETER PAN*, 1953 SCREENPLAY

Wonder is the heaviest element
on the periodic table. Even a
tiny fleck of it stops time.

~ DIANE ACKERMAN

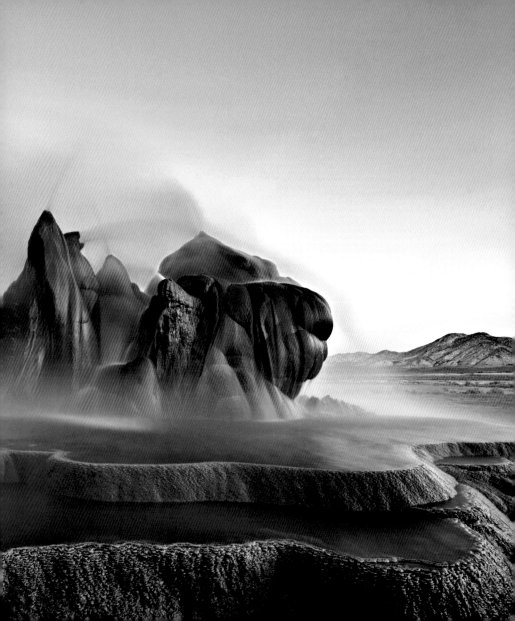

MARCH 22

Keep some room
in your heart for
the unimaginable.

~ MARY OLIVER

To be fully seen by somebody, then, and be
loved anyhow—this is a human offering
that can border on miraculous.

~ ELIZABETH GILBERT

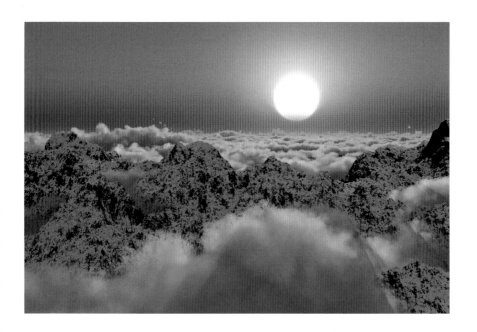

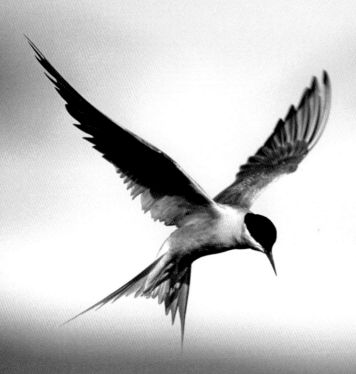

MARCH 20

The world changes when we change.
The world softens when we soften. The world
loves us when we choose to love the world.

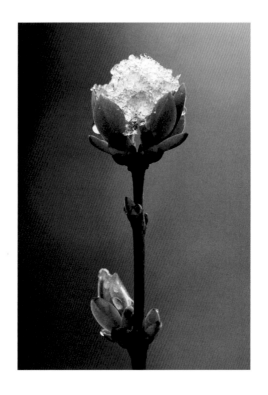

If you are in love—that's a good thing—that's
about the best thing that can happen to anyone.
Don't let anyone make it small or light to you.

~ JOHN STEINBECK

Like all magnificent things,
it's very simple.

~ NATALIE BABBITT, *TUCK EVERLASTING*

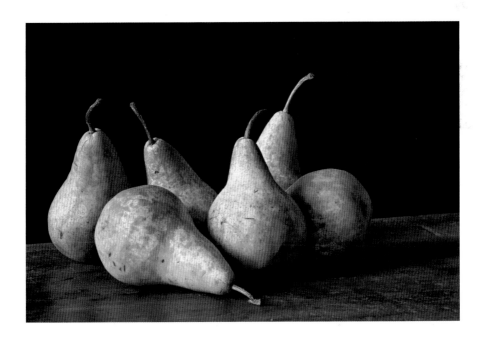

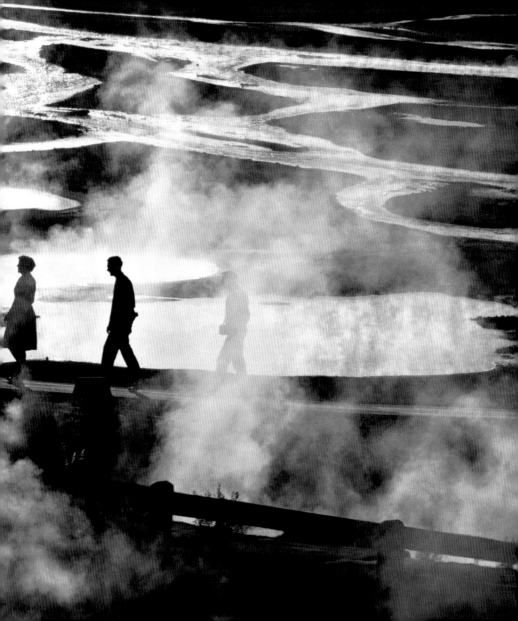

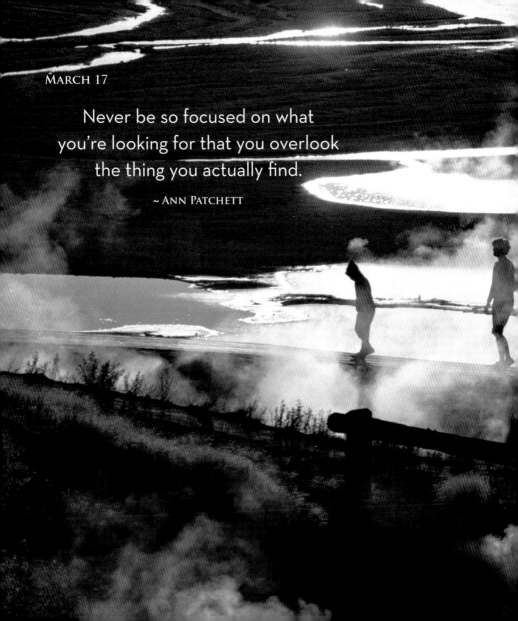

MARCH 17

Never be so focused on what
you're looking for that you overlook
the thing you actually find.

~ ANN PATCHETT

The poets are right: love is eternal.

~ E. M. FORSTER

MARCH 15

All my life, my heart has sought
a thing I cannot name.

~ HUNTER S. THOMPSON

Despite the thousands of years
of human interaction, it all
begins anew, as if for the first time,
when two people fall in love.

~ JOHN O'DONOHUE

MARCH 13

Where there is great love
there are always miracles.

~ WILLA CATHER, *DEATH COMES*
FOR THE ARCHBISHOP

MARCH 12

Only love can be
divided endlessly and
still not diminish.

~ ANNE MORROW LINDBERGH

The earth has its music
for those who listen.

~ REGINALD VINCENT HOLMES

March 10

Love makes your soul crawl out
from its hiding place.

~ Zora Neale Hurston

March 9

Love is like infinity: You can't have more or
less infinity, and you can't compare two things
to see if they're "equally infinite." Infinity just is,
and that's the way I think love is, too.

~ Fred Rogers

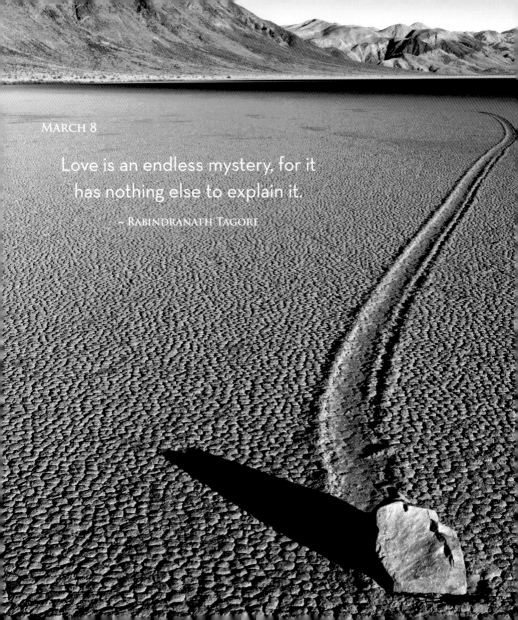

MARCH 8

Love is an endless mystery, for it
has nothing else to explain it.

~ RABINDRANATH TAGORE

A wonderful fact to reflect upon,
that every human creature is constituted
to be that profound secret and mystery
to every other.

~ CHARLES DICKENS, *A TALE OF TWO CITIES*

MARCH 6

Love is metaphysical gravity.

~ BUCKMINSTER FULLER

Love doesn't
need reason.
It speaks from the
irrational wisdom
of the heart.

~ DEEPAK CHOPRA

MARCH 4

Love weighs nothing.

~ BARBARA KINGSOLVER, *ANIMAL DREAMS*

When you begin to touch your heart
or let your heart be touched, you begin
to discover that it's bottomless,
that it doesn't have any resolution,
that this heart is huge, vast, and limitless.

~ PEMA CHÖDRÖN

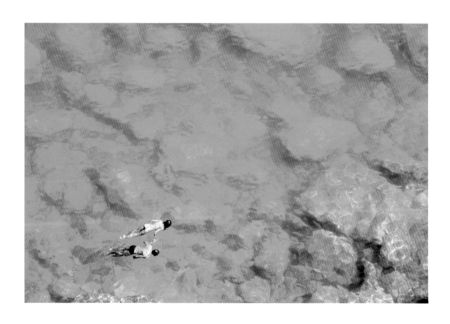

Let yourself be silently drawn by
the strange pull of what you really love.

~ RUMI

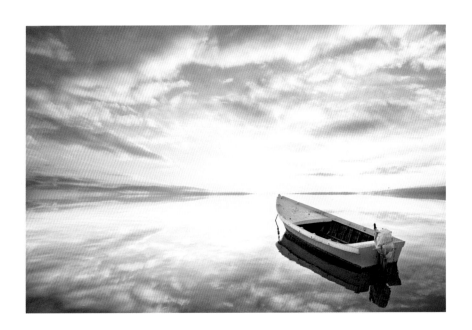

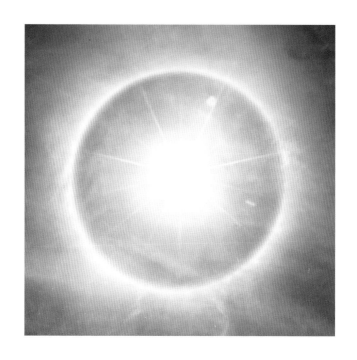

MARCH 1

Love is not consolation. It is light.

~ SIMONE WEIL

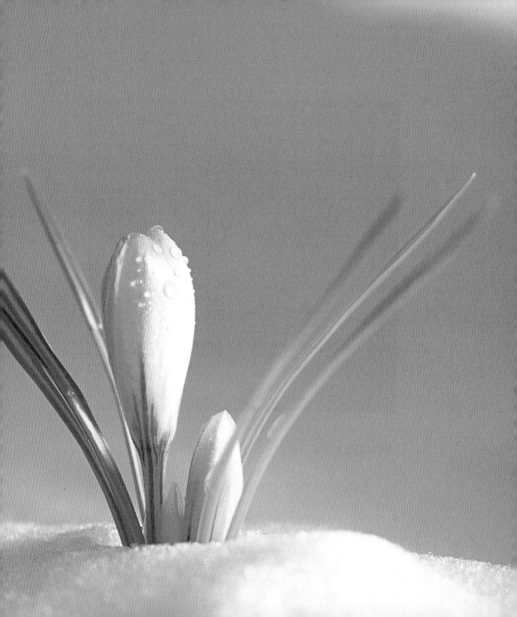

MARCH

WONDER

Stars should not be seen alone.
That's why there are so many.
Two people should stand together
and look at them. One person alone
will surely miss the good ones.

~ AUGUSTEN BURROUGHS

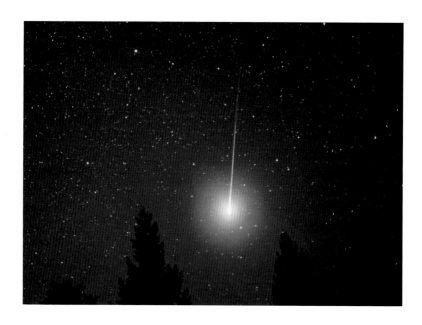

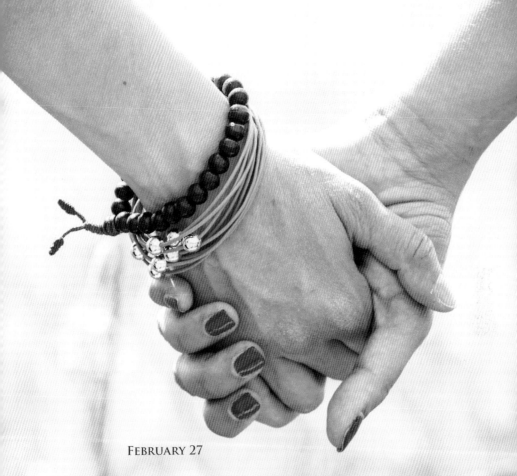

FEBRUARY 27

Holding hands is a way to remember
how it feels to say nothing together.

~ NICOLE KRAUSS,
THE HISTORY OF LOVE

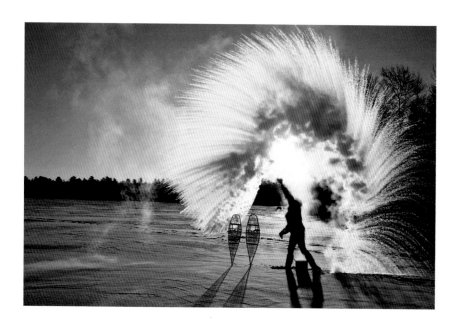

FEBRUARY 26

There is no magician
like Love.

~ MARGUERITE BLESSINGTON

Every heart sings a song, incomplete,
until another heart whispers back.

~ PLATO

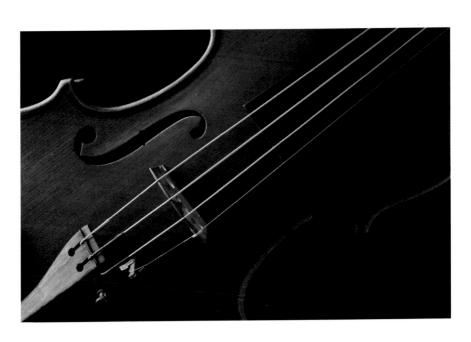

FEBRUARY 24

When you realize
you want to spend
the rest of your life
with somebody,
you want the rest
of your life to start
as soon as possible.

~ NORA EPHRON,
WHEN HARRY MET SALLY

FEBRUARY 23

Love has nothing to do
with good reasons.

~ HENRY JAMES, *THE PORTRAIT OF A LADY*

Speak low if you speak love.

~ WILLIAM SHAKESPEARE,
MUCH ADO ABOUT NOTHING

To lose balance sometimes for love
is part of living a balanced life.

~ ELIZABETH GILBERT

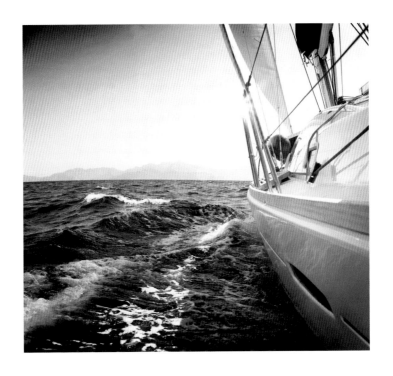

FEBRUARY 20

And think not you can direct the course
of love, for love, if it finds you worthy,
directs your course.

~ KAHLIL GIBRAN

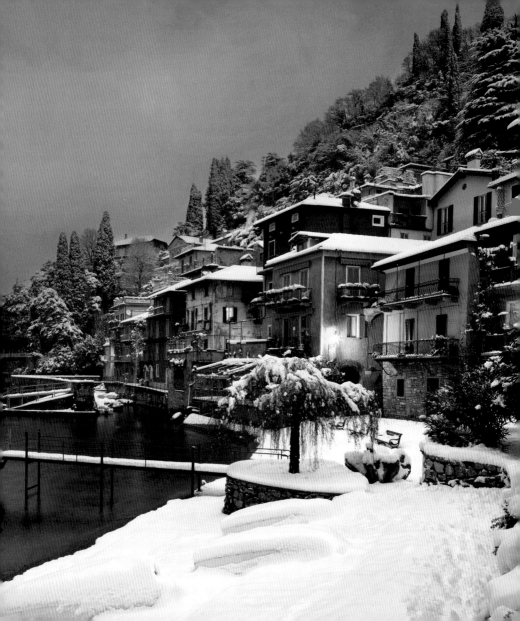

Day by day
and night by night
we were together—
all else has long been
forgotten by me.

~ WALT WHITMAN

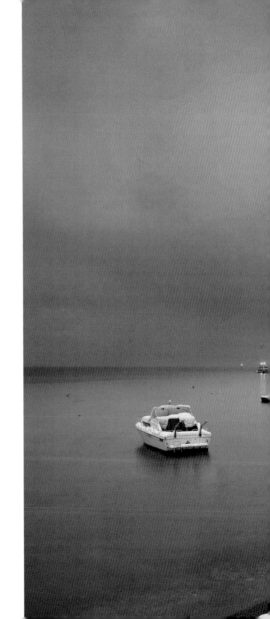

For this is love's truth: she joins two in one being,
makes sweet sour, strangers neighbors,
and the lowly noble.

~ HADEWIJCH OF BRABANT

February 17

Nobody has ever measured, even poets,
how much a heart can hold.

~ Zelda Fitzgerald

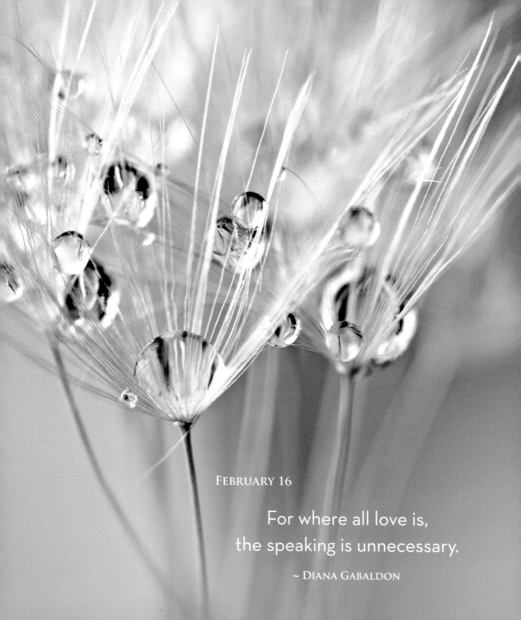

FEBRUARY 16

For where all love is,
the speaking is unnecessary.

~ DIANA GABALDON

The universe is full of magical things
patiently waiting for our wits
to grow sharper.

~ EDEN PHILLPOTTS

We are most alive when we're in love.

~ JOHN UPDIKE

FEBRUARY 13

What unites us as human beings
is an urge for happiness which
at heart is a yearning for union.

~ SHARON SALZBERG

When you're in love nothing
is so abstract or horrible that it
can't be thought of as cute.

~ DAVID SEDARIS

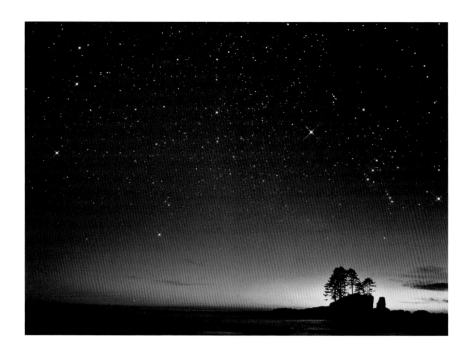

There are divine things more beautiful
than words can tell.

~ WALT WHITMAN

We love because it's the
only true adventure.

~ NIKKI GIOVANNI

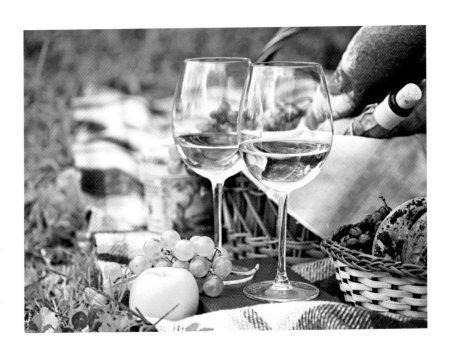

The one thing we can never get
enough of is love. And the one thing
we never give enough of is love.

~ HENRY MILLER

FEBRUARY 8

Let us be grateful to the people
who make us happy; they are
the charming gardeners
who make our souls blossom.

~ MARCEL PROUST

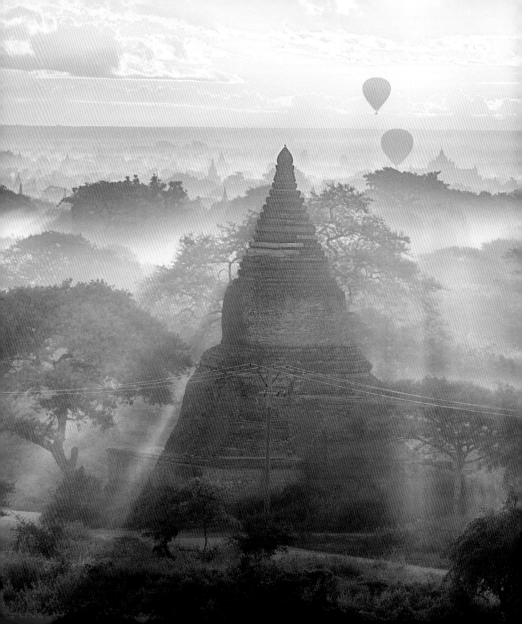

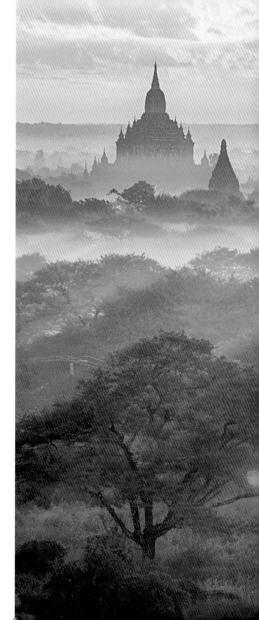

FEBRUARY 7

In the morning
there is meaning,
in the evening
there is feeling.

~ GERTRUDE STEIN

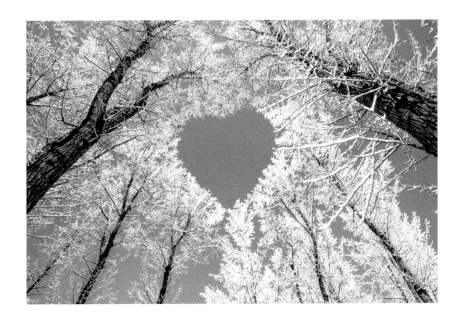

FEBRUARY 6

I love you also means I love you more
than anyone loves you, or has loved you,
or will love you . . . and also, I love you in a way
that I love no one else, and never have loved
anyone else, and never will love anyone else.

~ JONATHAN SAFRAN FOER,
EVERYTHING IS ILLUMINATED

First you get the feeling,
then you figure out why.

~ ROBERT M. PIRSIG

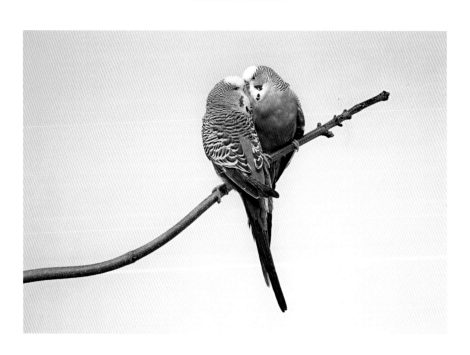

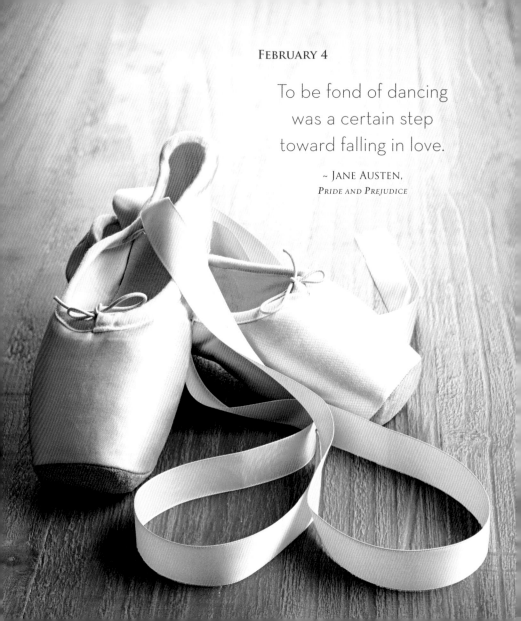

FEBRUARY 4

To be fond of dancing
was a certain step
toward falling in love.

~ JANE AUSTEN,
PRIDE AND PREJUDICE

February 3

The very essence of romance
is uncertainty.

~ Oscar Wilde

FEBRUARY 2

Lovers don't finally meet somewhere.
They're in each other all along.

~ RUMI

To love or have loved, that is enough.
Ask nothing further.

~ VICTOR HUGO, *LES MISÉRABLES*

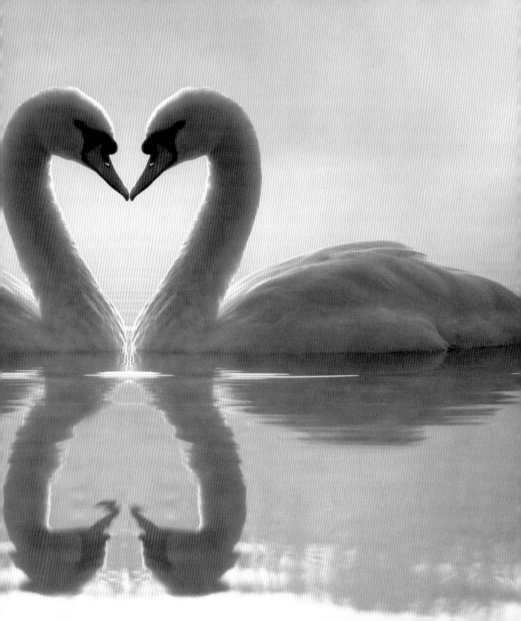

FEBRUARY
ROMANCE

JANUARY 31

And this more human love . . . the love
which consists in this, that two solitudes
protect and border and salute each other.

~ RAINER MARIA RILKE

There is nothing I would not do for
those who are really my friends. I have
no notion of loving people by halves,
it is not in my nature.

~ JANE AUSTEN, *NORTHANGER ABBEY*

The friend who holds your hand
and says the wrong thing
is made of dearer stuff than
the one who stays away.

~ BARBARA KINGSOLVER

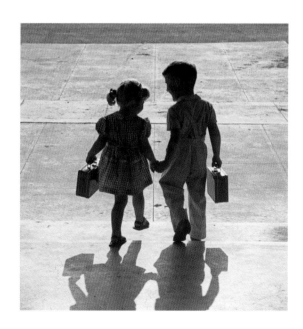

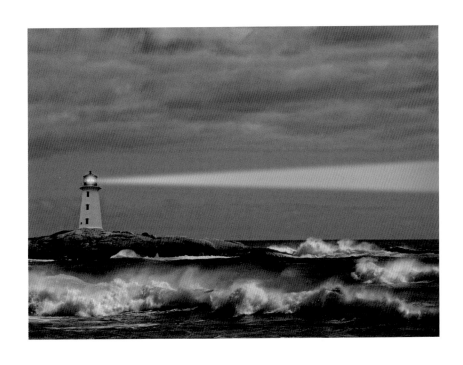

JANUARY 28

If you don't know what you love,
you are lost.

~ HARUKI MURAKAMI

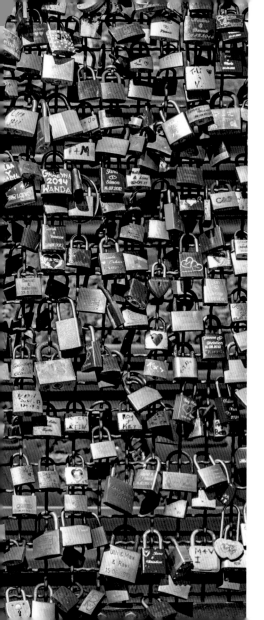

Love conquers
all things: let us too
give in to Love.

~ VIRGIL

JANUARY 26

To be rooted is perhaps the most
important and least recognized
need of the human soul.

~ SIMONE WEIL

To love another human in all of her
splendor and imperfect perfection,
it is a magnificent task ... tremendous
and foolish and human.

~ LOUISE ERDRICH, *THE LAST REPORT ON
THE MIRACLES AT LITTLE NO HORSE*

Life has taught us that love does
not consist in gazing at each other
but in looking outward together
in the same direction.

~ ANTOINE DE SAINT-EXUPÉRY

JANUARY 23

Love is or it ain't.
Thin love ain't love at all.

~ TONI MORRISON, *Beloved*

JANUARY 22

Love is not a because,
it's a no matter what.

~ JODI PICOULT, *SECOND GLANCE*

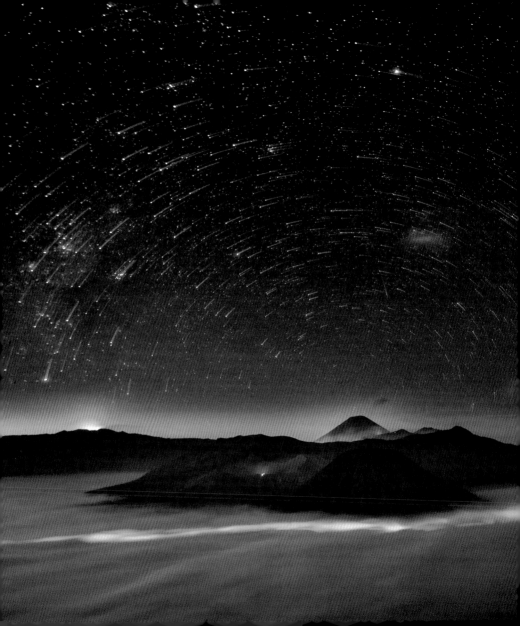

Love doesn't just sit there like a stone;
it has to be made, like bread,
remade all the time, made new.

~ URSULA K. LE GUIN

JANUARY 20

Love is, above all,
the gift of oneself.

~ JEAN ANOUILH

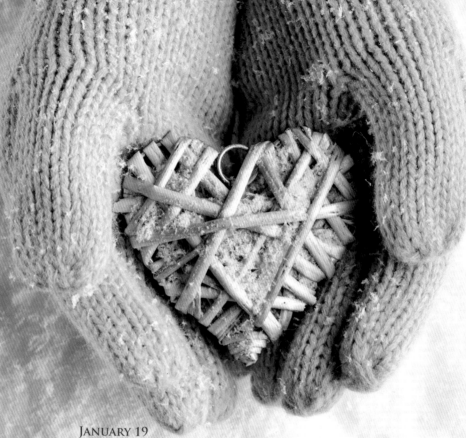

JANUARY 19

There is hardly a more gracious gift
that we can offer somebody than
to accept them fully, to love them
almost despite themselves.

~ ELIZABETH GILBERT

If there ever comes a day when
we can't be together, keep me in
your heart. I'll stay there forever.

~ A. A. MILNE

You have to work out whether your roots
have so entwined together that it is
inconceivable that you should ever part.
Because this is what love is.

~ LOUIS DE BERNIÈRES

JANUARY 16

And when you get down to it,
that's the only purpose grand enough
for a human life. Not just to love—
but to *persist* in love.

~ SUE MONK KIDD, *THE SECRET LIFE OF BEES*

One of the deep secrets of life is
that all that is really worth the doing
is what we do for others.

~ LEWIS CARROLL

JANUARY 14

Love is what you've been through
with somebody.

~ JAMES THURBER

Don't imagine that love, to be true
and burning, must be extraordinary.
No; what we need in our love is the
continuous desire to love the one we love.

~ MOTHER TERESA

That's what love is. Love is
keeping the promise anyway.

~ JOHN GREEN, *THE FAULT IN OUR STARS*

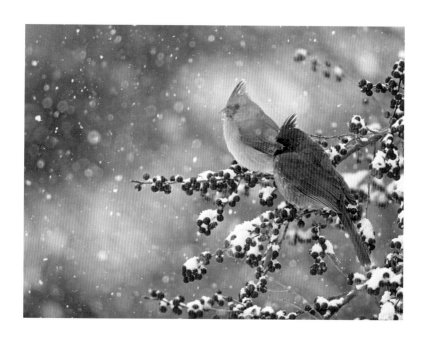

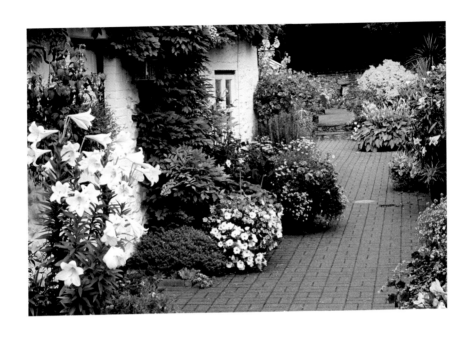

JANUARY 11

The art of love . . . is largely
the art of persistence.

~ ALBERT ELLIS

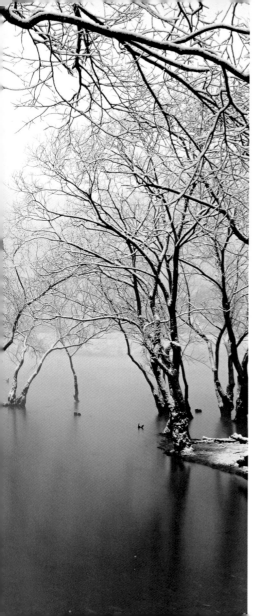

JANUARY 10

The greatest gift we
can make to others
is our true presence.

~ THICH NHAT HANH

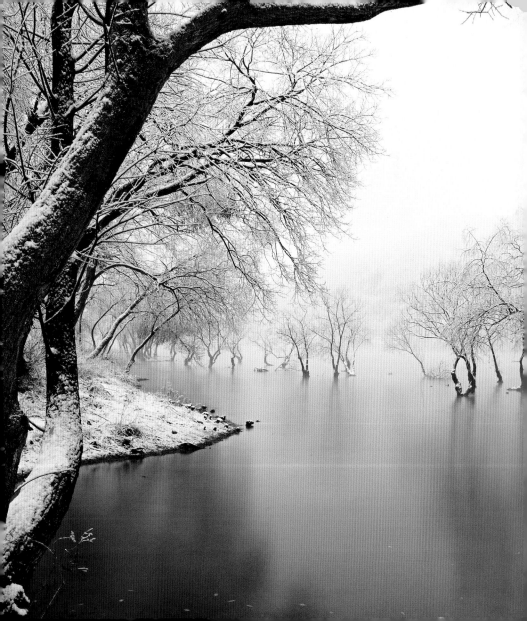

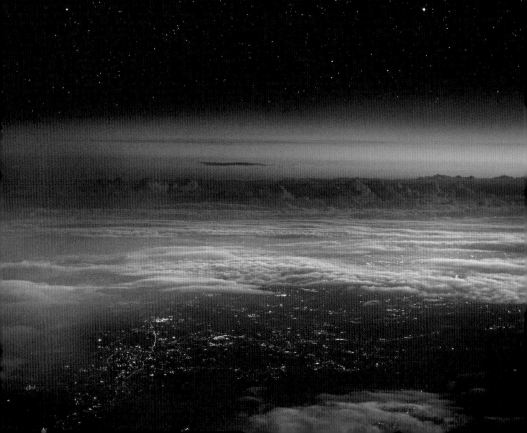

JANUARY 9

Things of great wonder come to those
who give their all to love.

~ HADEWIJCH OF BRABANT

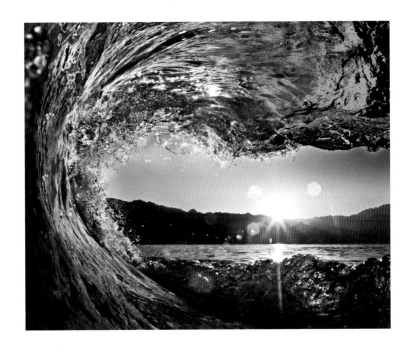

JANUARY 8

Love recognizes no barriers. It jumps hurdles,
leaps fences, penetrates walls to arrive
at its destination full of hope.

~ MAYA ANGELOU

JANUARY 7

Time is how you spend your love.

~ ZADIE SMITH

JANUARY 6

Happy the man who boldly dares
to defend the object which he loves.

~ OVID

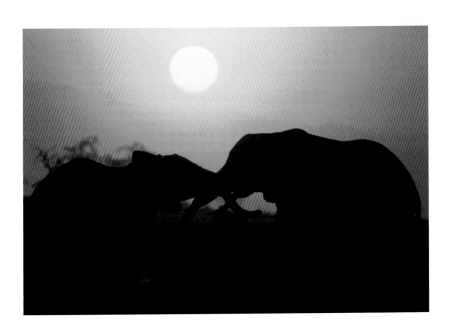

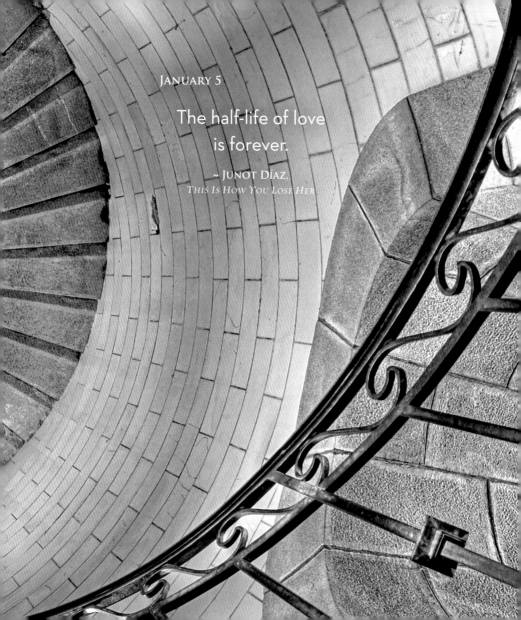

JANUARY 5

The half-life of love
is forever.

~ JUNOT DÍAZ,
THIS IS HOW YOU LOSE HER

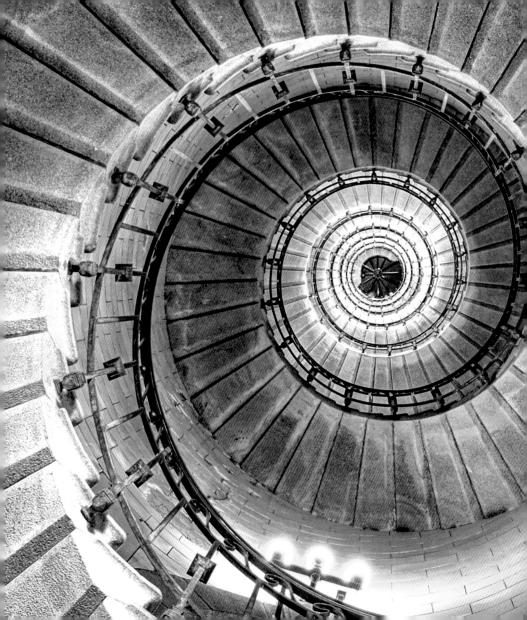

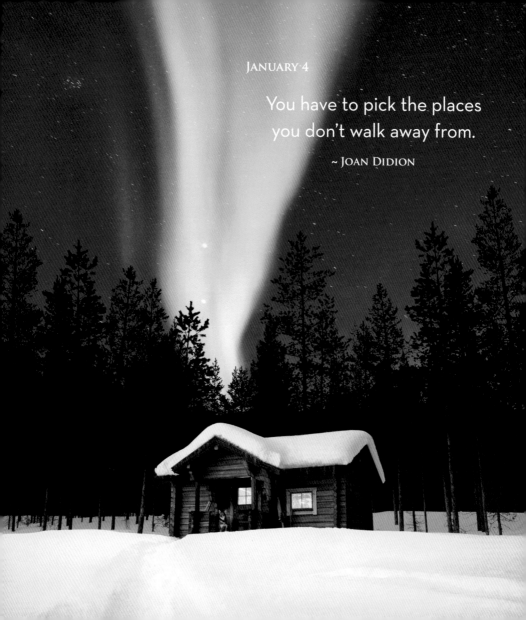

JANUARY 4

You have to pick the places
you don't walk away from.

~ JOAN DIDION

JANUARY 3

Things that matter most must never be
at the mercy of things that matter least.

~ GOETHE

JANUARY 2

To love deeply in one direction
makes us more loving in all others.

~ ANNE-SOPHIE SWETCHINE

If you can love someone with
your whole heart, even one person,
then there's salvation in life.

~ HARUKI MURAKAMI